The Book *of* Change

Published by
Princeton Architectural Press
202 Warren Street
Hudson, New York 12534
www.papress.com

First published in the UK in 2021 by September Publishing

Printed and bound in China
25 24 23 22 4 3 2 1 First edition

ISBN 978-1-64896-026-0

Design by Friederike Huber

For Princeton Architectural Press
Editors: Rob Shaeffer and Kristen Hewitt

Cover: *Red Cavalry* by Kazimir Malevich (Russian, 1879–1935),
oil on canvas, 1932

Library of Congress Control Number: 2021939078

The Book *of* Change

IMAGES AND SYMBOLS TO INSPIRE REVELATIONS AND REVOLUTIONS

Stephen Ellcock

Princeton Architectural Press, New York

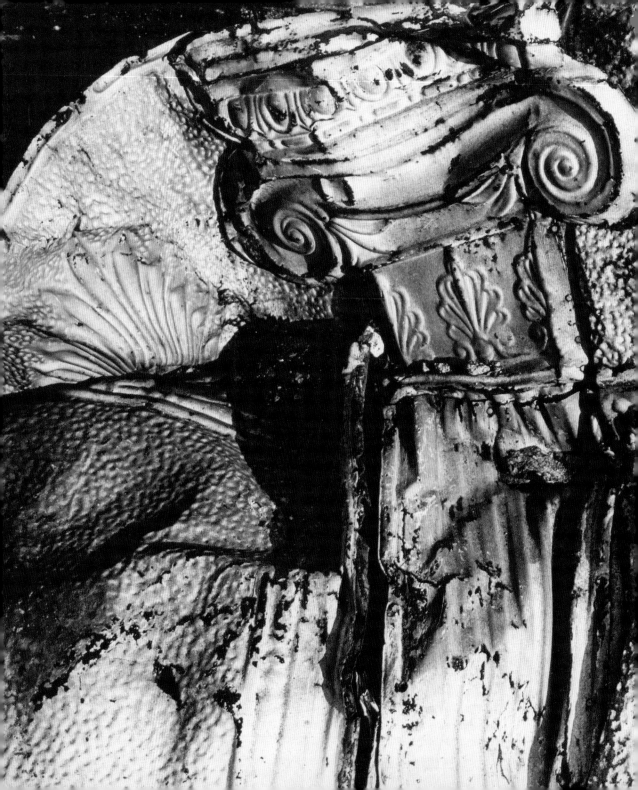

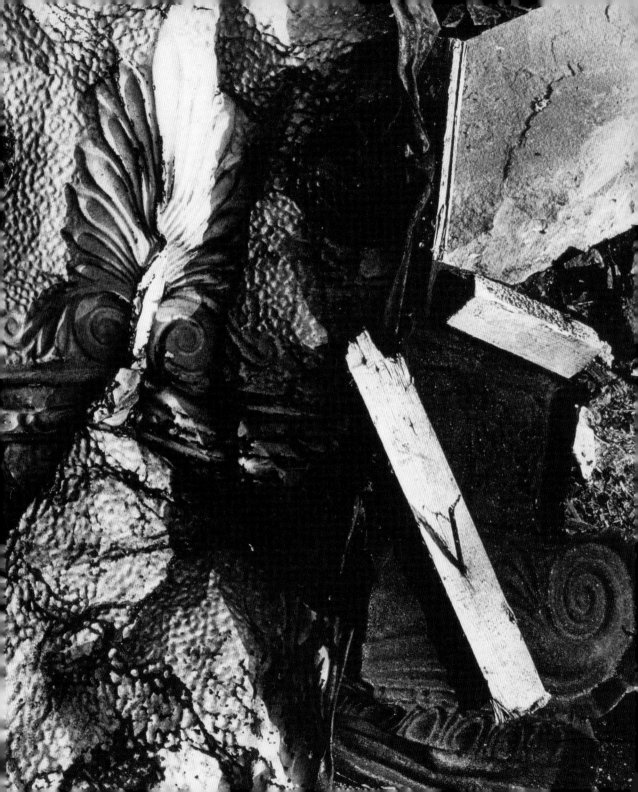

◁◁ Stamped Tin Relic by Walker Evans (American, 1903–75), gelatin silver print, 1929

▽ Cascus Cascam XXXVI from *Silenus Alcibiadis, sive, Proteus: Vitae Humanae Ideam, Emblemate Trifariàm Variato, Oculis Subijciens* by Jacob Cats (1577–1660), Frans Schillemans (b. 1575), Adriaen Pietersz van de Venne (1589–1662), and Jan Gerrits Swelinck (b. *c.* 1601), published by Ex Officina Typographica Iohannis Hellenij, 1618

▷▷ Kanonkopf nach dem Hexagramm from *Beuroner Kunst: Eine Ausdrucksform der Christlichen Mystik* by Josef Kreitmaier (German, 1874–1945), published by Herder, 1921

▷▷▷ *Eruption du Mont Vésuve* by J. M. Mixelle (French, 1758–1839) after Alessandro d'Anna (Italian, 1746–1810), mezzotint with etching, with gouache, *c.* 1787

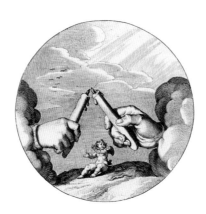

The Book of Change is dedicated to various
Humphreys and Ellcocks past and present,
and, above all, to Jackie, who is always
a true force for change in a retrograde world. x

Contents

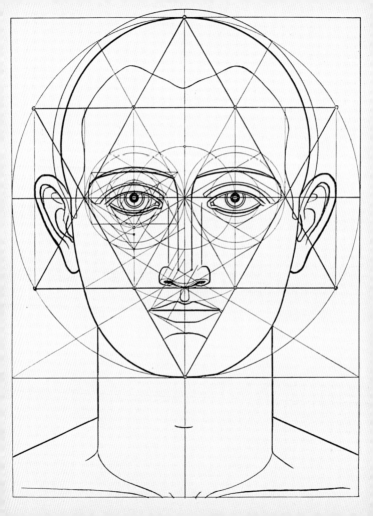

Introduction

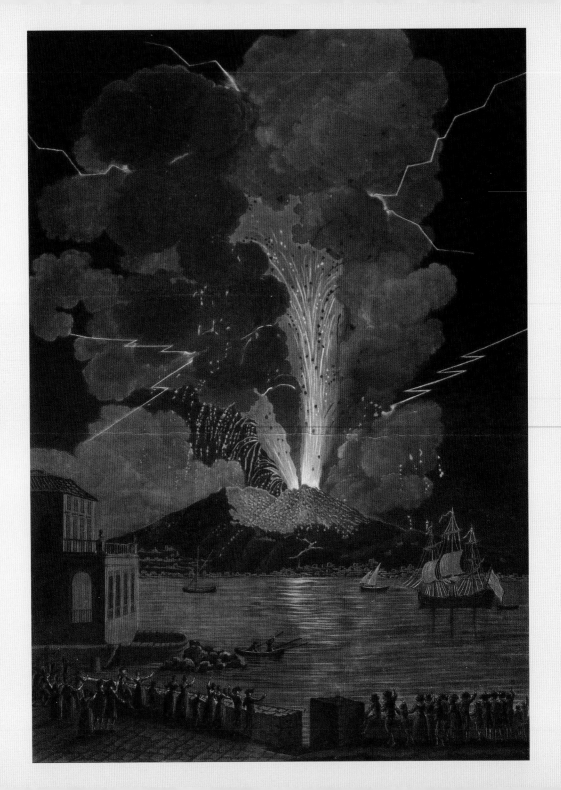

The Vampire's Mirror: Fragments from a Plague Year*

This book is born of a longstanding opposition to the way things are. I have always felt slightly at odds with the world, out of kilter, out of time, and permanently out of sorts. In the words of Edgar Allen Poe, "I have not been as others were; I have not seen as others saw."

I have never really expected much from society, and the potential rewards for good behavior that were constantly dangled before my eyes seemed to hold little appeal. Believing myself cursed with an ability to see through the deceit, subterfuge, and artifice of the world, I spent most of my life avoiding society's demands and expectations. Career; home; family; car; organized travel (as opposed to spontaneous, disorganized, unplanned flight); personal finance; a healthy credit rating; an active social life; hobbies; informed opinions about culture, literature, "must-see" art, film, or TV and the burning issues of the day; decency, decorum, and the respect of one's peers—all seemed to require far too much commitment and responsibility, too many compromises and accommodations, and, above all, time. Time that could be spent on the less complicated, headier pursuits of self-sabotage, the assiduous avoidance of phone calls and doorbells, and ignoring official-looking mail.

By the time I came to realize, following a serious illness, that having a permanent roof over my head and having access to most modern conveniences and utilities was not such a bad or demeaning idea after all, I discovered that those rewards were no longer on offer, at least not for the feckless no-good likes of me. My life has been punctuated and pock-marked by as many wrong turnings, missteps, betrayals, blunders, pratfalls, and cringe-making compromises as anybody's, but, in spite of everything, I have always jealously guarded and tried my best to cultivate and nurture my moral imagination and political conviction, and I am continually driven by an overwhelming, gnawing frustration at the injustices of the world and an intense desire for something better.

This book is, in part, a response to that life-long sense of alienation and dislocation. But it is also a response to the situation in which we now find ourselves in 2021, on both the micro and the macro level.

* In Bram Stoker's *Dracula*, the author invented the superstition that vampires cast no reflection. In the novel, Castle Dracula contains no mirrors or reflective surfaces. Jonathan Harker, the youthful English solicitor sent to Transylvania to conclude a property deal with the count, brings along his own shaving mirror and discovers that Dracula casts no reflection. His true nature having been revealed, the vampire angrily snatches the mirror from Harker's hand and hurls it through a window where it smashes in the courtyard below—a reference to both the vampiric traits and tendencies of those who currently lord it over us and the apparent lack of consequences or meaningful retribution for their actions and egregious misdeeds.

*

In compiling *The Book of Change* my aim was to combine fragments of the visual culture of the past—drawing upon as many different traditions, geographical locations, and eras as possible—with work by contemporary artists and photographers and illustrators, to create a unique patchwork that attempts to reimagine and extract some inspiration from the raw material of the world.

There were moments during the creation of this book when I felt that unnamed dark forces, a sinister cabal of social media trolls perhaps, or a rogue cell of embittered centrists and carnivores, were conspiring against me and the book would never be completed. Following a brush with COVID-19 at the end of 2020 and a lengthy recuperation, and just as I was about to put the final touches to the book, I was ambushed by a cunningly concealed tree root and crash-landed onto the pavement, shattering the bones in my right arm and elbow. This necessitated a lengthy stay in hospital and a major operation to replace the shattered bones and elbow with metal and plastic components, and another lengthy period of recuperation and intensive physiotherapy. So I am opening the book with a compilation of fragments and observations, typed out with my thumb on my phone.

*

Of all the reliable surviving memories of childhood that I can still retrieve from the sinkhole of my much-abused subconscious, there are few more significant or more haunting than the moment when my maternal grandfather suddenly, without warning, ceremony, or precedent, decided to unburden himself of his own memories and trauma. A trauma, buried deep and wrapped tightly in a shroud of silence for 50 or more years, that is as unimaginable to me now, as I find myself all-too-rapidly approaching the age of my grandfather at the time of his confession, as it was to my ten-year-old self.

My grandparents were from modest, rural backgrounds; their families were agricultural laborers, fruit pickers, tractor drivers, mechanics, servants, and housemaids, the sons and daughters of toil and soil. One great-uncle owned or managed a butcher's shop, I believe, but that was about as affluent and socially mobile as they got. Nevertheless, my grandparents appeared, on the surface at least, to enjoy lives full of compensation and consolation.

In common with most women born into her class and time, my grandmother had been forced to leave school at an early age to enter "domestic service," usually a thankless, demeaning life of drudgery, gross exploitation, and subservience to one's "betters." However, being drafted into working in a munitions factory during the First World War released my grandmother from domestic servitude and gave her a new sense of purpose, unleashing her inner militant and firebrand, and she became a committed member of the Labour Party and a trade union organizer, associations she maintained for the rest of her life.

My grandparents owned very little in the way of worldly goods, but my grandfather's lovingly tended garden and toolshed proved an endless source of wonder and mystery, as did the contents of their glass-fronted bookcase of poetry anthologies, Shakespeare, and Dickens. There were atlases too (featuring place names and countries that had ceased to exist or been erased from history, colonized, conquered, and renamed many decades before I, or even my parents, were born), gazetteers and "ready reckoners," illustrated histories of the world, introductions to great minds, great inventions, histories of science and technology, natural history, *The Living Races of Mankind*, Sherlock Holmes, H. G. Wells, etc. These two

or three modest shelves contained enough magic and intrigue to cast a lifelong spell.

As far as I am aware, my grandmother never once traveled abroad during her long and active life. My grandfather was forced to leave the country as a conscripted private in the First World War, but that was, I believe, the only time he set foot on foreign soil.

Every summer during my childhood, my grandparents would be invited to stay with my parents, my sister, and I for a week or so, wherever we happened to be living at the time. These visits would usually follow a predictable pattern: regular walks, the occasional spot of sightseeing, courtesy calls from uncles and aunts of uncertain propinquity characterized by awkward silences and stilted small talk.

However, one summer afternoon during the late 1960s, predictability, banality, and equanimity were momentarily shattered without warning by an eruption of the unexpected. Seated around the table for tea, my grandfather suddenly launched unprompted into a lengthy monologue describing in eloquent and devastating detail his experiences at the front during the First World War. He spoke in measured, dispassionate tones, but I can still recall many of his words almost verbatim, particularly the part where he described the feeling of being shipped back home on leave knowing that he would be returning to Hell in but a few short days' time.

My grandmother and mother were both quite astonished. They had never heard my grandfather speak about his wartime experiences at such exhaustive length before. It was as if he were impelled suddenly to unburden himself of these long-suppressed memories, perhaps as an education for my sister and me.

My grandfather lived for another 15 years, but according to my grandmother he never mentioned the war in her presence again.

*

In strictly material terms, my parents' generation benefited enormously from the sacrifices and struggles of those who lived through two world wars and the intervening economic meltdown and depression, and particularly from the postwar settlement and consensus, which in the UK led to the establishment of the welfare state.

Consequently I and my contemporaries were born into a world of apparently unparalleled privilege for someone of my class and circumstances: free health care, free higher education, the promise, at least, of social mobility. For my grandparents, concepts such as university education, home ownership, affordable foreign travel, cars, easy credit, a superabundance of luxury goods, and labor-saving devices would have seemed completely unattainable.

My grandparents had always lived in rented accommodation or social housing. When Margaret Thatcher introduced her phenomenally successful policy in the 1980s of selling off social housing stock to sitting tenants at bargain-basement prices to create a nation of "homeowners" (a.k.a. an utterly unscrupulous and insidious experiment in social engineering and mass bribery) they dismissed the idea of home ownership out of hand, even after my father offered to pay their estimated pittance of a mortgage for them.

What was the point of buying their home? It was a community asset, one to be passed on to others in need of decent, affordable housing once they were no longer around. Given governmental hostility toward social housing and the relentless, all-pervasive propaganda aimed at demonizing tenants at the time, grabbing such an irreplaceable asset for one's own personal gain would have seemed tantamount to theft from the wider community.

The brief interregnum between the end of the Second World War and the inexorable ascendancy of Reagan, Thatcher, and the neoliberal Pax Moronica offered an all-too-brief

respite from a thousand years of feudalism, piracy, and subjugation. Now there was play-time for the proles, a brief window of opportunity to escape your allotted station in life and to grab as many lovely, shiny new things as you could, while you could.

These prizes and rewards came at a heavy price. The deliberate fragmentation of society, the ruthless pursuit of atomization and alien-ation, the wanton destruction of communities, the fracturing of social bonds, and the poison-ing of the collective spirit, together with the sledgehammer policies of divide and rule—the time-honored coup de grâce that never fails—left vast swathes of the population unmoored, disenfranchised, adrift, and insecure, chasing phantoms and seeking consolation and valida-tion from the very sources of their unease, from those who would devour their souls without a second thought. At its most unhinged and ex-treme this sense of alienation mutated into a form of psychosis, casting around for scape-goats and enemies both within and without a population consuming itself, at war with its own best interests.

Everything that was briefly held in common and in which all had a stake was once again stolen and appropriated and is now safely in the hands of the very few. The same very few whose actions, greed, and appetites had led the entire world to the brink of destruction at least twice within recent memory, and whose insatiable maraudings and incessant gaslight-ing of punch-drunk populations are dragging us headlong to the brink again. This time to the brink of total extinction.

*

In recent years successive governments have attempted to roll back history, to undo much of the progress toward social justice and equal-ity that has been made during my lifetime, riding roughshod over hard-won victories in a determined effort to reassert ancient hierarchies and to put the uppity peasants, pesky proles, and insubordinate serfs back in their rightful place.

This reestablishment of the natural order of things has been engineered as an exercise in mass hypnosis and misdirection in order to enable the plundering of the public purse, the appropriation of communal assets, and the hoarding of the earth's rapidly dwindling supply of irreplaceable resources by the very few. Battles I assumed had been won long ago are having to be fought all over again; argu-ments I believed had been settled once and for all are having to be engaged in yet again.

This prospect could be soul-destroying, but if the events of the recent past have taught us anything, it is that there are millions among us more than ready, willing, and able to fight these battles and win these arguments anew.

Younger generations on every continent are not prepared to simply roll over and be swin-dled out of their dreams and forfeit their futures for the sake of a system built on lies, violence, and gluttony. The hour may be late and the light is fading, but there is still all to play for.

*

I have always felt there can be no true and lasting justice until justice is established for all living beings on this planet. Every individual struggle for justice, equality, peace, and recog-nition should be part of a collective effort. Each struggle should be inextricably linked and indivisible—the quest for justice should not be a zero-sum game.

For example, many self-proclaimed "pro-gressives" are dismissive of transgender rights or veganism. This is, of course, their preroga-tive, although I happen to believe that history will prove them wrong.

There can be no true peace and justice until the battles for such rights are won, and until the mass exploitation and wholesale slaughter of

our fellow sentient creatures are regarded with the same sense of revulsion and disgust with which we now regard other once-acceptable barbaric practices and traditions of the past.

*

"For the master's tools will never dismantle the master's house. They may allow us temporarily to beat him at his own game, but they will never enable us to bring about genuine change. And this fact is only threatening to those women who still define the master's house as their only source of support."
—Audre Lorde, "The Master's Tools Will Never Dismantle the Master's House," 1984

*

To those of us living among the squalor, grime, and hastily patched-up ruins of exhausted, morally bankrupt, collapsing empires, the years prior to the momentous and terrifying events of 2020, the years of the triumphalist neoliberal consensus, felt at times like a long, slow trudge through the post-imperial boneyards of a dying world on a one-way trip to oblivion, irrelevance, and catastrophe.

Throughout the economies of the Western world, and increasingly beyond, traditional narratives of resistance were in danger of becoming stale, exhausted, and repetitive, drowned out by the relentless bluster, braggadocio, and deafening cacophony spewed forth from the gaping mouthpieces and insatiable maws of those who hold the reins of Power and Capital. In this respect, 2020 felt like an unscheduled stop at the Last Chance Saloon and this unforeseen interruption to normal programming also happened to provide a rare opportunity to confront some noisome ghosts.

*

Every time you retrieve something from the past you are resurrecting ghosts. By reassembling, repurposing, and repositioning fragments of the past and combining them with new visions and fresh ways of seeing, a collage of unfamiliar, unspoiled possibilities can emerge, exorcising the ghosts of struggles, failures, and traumas past, providing glimpses of a better world, of overgrown paths in the clearing, of potential routes out of crisis into a brighter, bolder future.

If Art is to have any meaning, relevance, or use in the wider world whatsoever, then it must play its part when it comes to laying these ghosts to rest.

*

A loose coalition of the self-sustaining, mutually supportive superrich is robbing us of our futures and will never cease its dance of death until it robs your children and your children's children of their futures too—unless the means, stratagems, and collective willpower is found to stop it in its tracks before we pass the rapidly approaching point of no return.

The idea of "hardworking tax payers" that is constantly promoted as the one and only officially sanctioned and acceptable lifestyle option open to the responsible citizen has actually resulted in a population of wage slaves on zero-hours, part-time, and insecure incomes; indentured laborers paying off ever more debt under the delusion that they are "homeowners" not "serfs."

Information is never neutral. A war of cruelty, incompetence, and neglect is being waged upon us by our own "betters" and "leaders." Day after day, men (and they are almost always men) without shame, installed between flags, repeatedly spout outrageous lies, and no one seems to mind very much.[**]

Mass media has been presenting a vision and explanation of the world to us, using the same images, tricks, words, and tropes for too long.

[**] Thanks to my friend Anthony Donovan for this image.

It is not that people are insensitive or inured to the horrors and injustices of the world, it is that oversaturation, constant dissembling, and bludgeoning repetition have rendered us bored, benumbed, and far too easily manipulated.

The structures of power will eventually collapse if we make a collective decision to refuse to buy into their lies, to swallow their tawdry fictions, their fairy tales and fables of social mobility, of merit rewarded, of kind and tender butchers, of self-sacrificing, meek, angelic buccaneers, and death squads blessed with hearts of gold.

If we no longer take for granted the inviolability of the Market and of property rights, if we unsubscribe from their version of history, if we deny the inevitability of the status quo and refuse to sacrifice our hopes and freedoms in order to borrow or scrape together enough to buy a poisoned apple or handful of magic beans, then, and only then, will the prospect of true and lasting change become a genuine possibility and our real work can begin at last.

<p align="center">*</p>

"While there is a lower class, I am in it,
while there is a criminal element,
I am of it, and while there is a soul
in prison, I am not free."
—Eugene V. Debs at his sentence hearing for sedition, September, 1918

<p align="center">*</p>

The Book of Change is my own modest attempt to address urgent issues affecting every single living organism on the planet. By combining disparate elements and images in these pages, I hope to expose certain mechanisms of power clearly enough to reveal how they work and in a way that may encourage people to recognize the necessity of changing their own reality. I want to make people realize the vital importance of collective struggle and solidarity and acknowledge the urgency with which we need to confront the power dynamic controlling the modern world; how that dynamic mutates, how it hides, and how the world is shaped by invulnerable vested interests.

I don't claim to speak on behalf of anybody apart from myself, yet because I've been fortunate enough to have the time to devote to finding all this extraordinary material, I feel privileged to be able to share it with anybody who is kind enough to cast their gaze in my direction. For me, it's important that the images come from as many different sources as possible. When I started using Instagram it was almost a game for myself, spotting and sharing correspondences and repeating patterns. Followers can see that this image relates to not just its neighbor but a piece that was posted several weeks previously. And I hope that's something readers will take from this book as well.

In order to do justice to these themes and lend the finished book a necessary touch of gravitas I felt that the least I could do would be to present them in a time-honored, classic framework, drawing on the traditional narrative arcs that characterize the great, enduring religious texts, myths, and epic verses and literature. The archetypal themes of a lost paradise, of hubris and nemesis, of broken covenants and promises, of a fall from grace, of struggle, hope and possibility, and of ultimate redemption are all key. The Wonderful moves the memory more than the Ordinary.

I have found social media to be the most effective medium for transmitting and delivering an extraordinarily diverse selection of images to a larger, global, and gratifyingly receptive audience far beyond that still small constituency of people who visit our latter-day temples of culture armed with their bucket lists of cultural touchstones, dutifully ticking off each "must-see" artifact and blockbuster show as they go. I am extremely uncomfortable with the term "outside art," but I have tried to

include quite a few images within *The Book of Change* from art from beyond the mainstream and the confines of the art world, often by self-taught artists with no formal training. It's worth remembering what Toni Morrison said when asked about Ralph Ellison's book *Invisible Man*: "Invisible to whom?"

*

"Life's spell is so exquisite, everything
 conspires to break it."
 —Emily Dickinson, from a letter, 1873

*

The first section of the book, SOURCE, opens with the creation of the planet via the painted doors of the Hieronymus Bosch triptych *The Garden of Earthly Delights*. Bosch's masterpiece shows the world on the third day of creation, after God has made plants but before animals and humans have appeared on the scene. Also in this section is a Persian miniature of a scene from *Mantiq al-tair* (*The Conference of the Birds*), a 12th-century poem by the Sufi poet Farid al-Din 'Attar, in which the birds of the world gather to choose a king, eventually deciding that their ideal leader will be the mythical Simurgh bird.

This introductory section features Edward Hicks's painting *The Peaceable Kingdom* as well, which portrays a menagerie of slightly startled animals dropped into the New World in an interpretation of Isaiah's biblical prophecy that animals and infants will live together in a paradise on earth. Much like in the Garden of Eden in Genesis, however, a serpent lurks—in this case in the form of the British Quaker William Penn negotiating a treaty with the Lenape people in the background. Penn's treaty was kept for 70 years until the Penn's Creek Massacre of 1755, when 14 settlers were killed after encroaching on Lenape land.

*

The second section of the book is FALL. It begins with a literal fall, in the form of Icarus's nosedive, with a sculpture by Auguste Rodin—and the section as a whole takes on the theme of our casting out from paradise. There are depictions of Hell and demons here, as well as *Fable of the Dog and the Prey* by the Flemish Baroque painter Paul de Vos, a painting inspired by Aesop's fable about a greedy dog who sees his reflection in a river while he holds a chunk of meat in his mouth, tries to grab the "extra" slab reflected in the water, and loses the original piece in the process. This sits next to Caravaggio's masterful *Narcissus* of a handsome youth gazing lovingly at his reflection in a pool, a commentary on the dangers of self-obsession that speaks with great clarity to our present times.

*

CONNECTIONS is about the way that human beings have responded to the world, to both the beauty and the danger of it. In this part of the book, there's a sense of the many ways that humans have used ritual, magic, and belief systems to make consoling connections as a way to anchor ourselves. Magic is a way of thinking beyond the circumstance in which we find ourselves. This section opens with two contrasting depictions of the Madonna and the infant Christ from outside the mainstream of European tradition and iconography: *The Virgin and Child with the Archangels Michael and Gabriel* from a 16th-century Ethiopian Gospel and the *Virgen de Belén*, by an unknown artist from Cuzco School, Peru, dating from the 18th century.

A pre-dynastic Egyptian terracotta female figurine from the 4th millennium CE is juxtaposed with an ecstatic "witch woman" from the 1950s by artist, occultist, and countercultural icon Marjorie Cameron. Both figures, created some 4,500 years apart, strike remarkably similar, ritualistic poses. I've

included images of Hopi Kachina dolls, which were carved figures used to teach young girls and new brides about mythical gods and goddesses that could control the weather and the world, and act as liaisons between the earthly and spirit worlds. This section also features a George Catlin image of a Sac or Fox nation dance celebrating "berdash" or two-spirited people, individuals within the tribe who were supposed to embody both male and female characteristics.

*

LOSS deals with economic exploitation, the pitfalls of industrialization, and the class system. Here are images drawn from slavery, by both historical and contemporary artists, including Kara Walker's powerful image of a slave ship in the middle passage, Black hands holding up the ship. *The Arrival of the Jarrow Marchers in London, Viewed from an Interior* is a little-known work by the British artist Thomas Cantrell Dugdale, showing a wealthy woman leaning out of a window watching the Jarrow marchers assembling in London to protest unemployment and poverty in 1936 while her disinterested, rather louche husband or lover sits beside her blowing smoke rings, not even bothering to look out of the window.

*

LIES opens with a detail from Ambrogio Lorenzetti's series of frescoes from 1337–39, known as *The Allegory of Good and Bad Government*. The figure may have been created some 700 years ago, but the grotesque, demonic visage of the pitiless tyrant, the very embodiment of Bad Government, complete with fangs, horns, and cold dead eyes, may seem an all-too-familiar figure to many of my readers.

This section examines how economic and social forces lead to alienation, the breakdown of society, chaos, and dismay. There are images that represent war, ecological damage, exploitation, and the impact of man on the natural world. Here is Käthe Kollwitz's *The Mothers*, from a series of woodcuts made in the early 1920s, where women are depicted protecting their children from the horrors of the First World War (Kollwitz, an ardent pacifist, lost her own son during the war).

*

The penultimate section, RISE, is about methods of reacting against oppression, of organizing people, and of claiming the right of activism. It features images of the civil rights, suffragette, and abolitionist struggles, and LGBTQ+ liberation.

I am in training don't kiss me by Claude Cahun (born Lucy Schwob) delivers a typically brilliant combination of humor, provocation, surrealism, and photographic composition. During the Second World War Cahun—along with her life-long partner, artistic collaborator, and stepsister Marcel Moore (born Suzanne Malherbre)—waged a campaign of artful resistance against German forces occupying Jersey. They convinced the Germans that the island hosted a large and vigorous opposition, not just two eccentric, middle-aged "sisters." "Masculine? Feminine? It depends on the situation," Cahun wrote once. "Neuter is the only gender that always suits me."

This section also includes two remarkable apocalyptic visions by 19th-century English artists, both created during the years before Victoria ascended to the British throne, and a mere decade or two before the orgy of Empire-building, colonization, and exploitation her nation had embarked upon over the course of the preceding centuries was about to reach its climax. These two works—J. M. W. Turner's *The Burning of the Houses of Lords and Commons, 16 October 1834*, an eye-witness depiction based upon the many sketches the artist made on the night of the great

conflagration, and *Bank of England as a Ruin* by Joseph Michael Gandy, the visionary artist architect, and former employee and partner of Sir John Soane, the architect responsible for the Bank of England—presage the inevitable, inescapable final fate of Empire and of Empire builders: disaster, ruin, decay.

<center>*</center>

The concluding section, HOPE, returns us full circle, back to the prelapsarian world glimpsed in the opening section, concluding with visions of rebirth and transformation, of new beginnings and fresh horizons, of celebration and resurrection, and of tenderness and hope.

A central theme of this this final section is that of Space, of exploration and of extraterrestrial encounters, including a photo taken by *Apollo 16* astronaut Charles Duke of a plastic-encased photo portrait of his family that he left behind on the surface of the Moon. The reverse of the photo was signed and thumbprinted by each member of Duke's family and bore this message: "This is the family of Astronaut Duke from Planet Earth. Who landed on the Moon, April 1972."

Esther Pearl Watson is a contemporary artist who often includes unidentified flying objects or flying saucers in her work, drawing on memories of her father, who was fascinated with UFOs and believed that he could build a working flying saucer and sell it to NASA.

I have also included two images from Spanish photographer Cristina de Middel's series *The Afronauts*, which employs highly theatrical staging and costume to confront conventional, stereotyped representations of African people and culture. The inspiration behind *The Afronauts* was the story of the eccentric Zambian teacher Edward Makuka Nkoloso, who in 1964 launched his own space program as a rival to the United States and the Soviet Union, the aim of which was to put the first African on the Moon. Unfortunately, Nkoloso

was forced to abandon this extraordinary and visionary project after a few short months due to a lack of funding from the Zambian government, the United Nations, or any international organization, institution, or foundation.

<center>*</center>

My intention in creating *The Book of Change* is not only to confront the past and the present but also to provide a signpost for the future, a book that serves as a visual manifesto for a better world. I hope, too, that its arc encompasses suffering and loss, and gives consolation. So many have lost so much. My deepest wish is that it gives people a glimpse of different possibilities. I would count it a great success if the selection and arrangement of images featured within this book inspires just a single reader to shed illusions and preconceptions, to see through the world of lies and deceit, to become wise to its tricks, and to dream the world anew.

Stephen Ellcock, April 2021

I respect kindness in
human beings first of all,
and kindness to animals.
I don't respect the law;
I have a total irreverence for
anything connected with society
except that which makes the
roads safer, the beer stronger,
the food cheaper, and the
old men and old women
warmer in the winter and
happier in the summer.

—Brendan Behan (1923–64)

Images

Source

All that you touch
You Change.
All that you Change
Changes you.
The only lasting truth
Is Change.
God
Is Change.

—Octavia E. Butler, *Parable of the Sower*, 1993

◁◁ *TZN03 (Timizu Nu In)* by Roosmarijn Pallandt (Dutch, b. 1977), platinum print on Japanese washi, 2021

▽ Shutters from *The Garden of Earthly Delights: Genesis of the World* by Hieronymus Bosch (Dutch, *c.* 1450–1516), grisaille and oil on oak panel, 1490–1500

▷ Schematic map of the world, artist unknown, from Jean Corbichon's translation of *De proprietatibus rerum* by Bartholomaeus Anglicus, French, 15th century

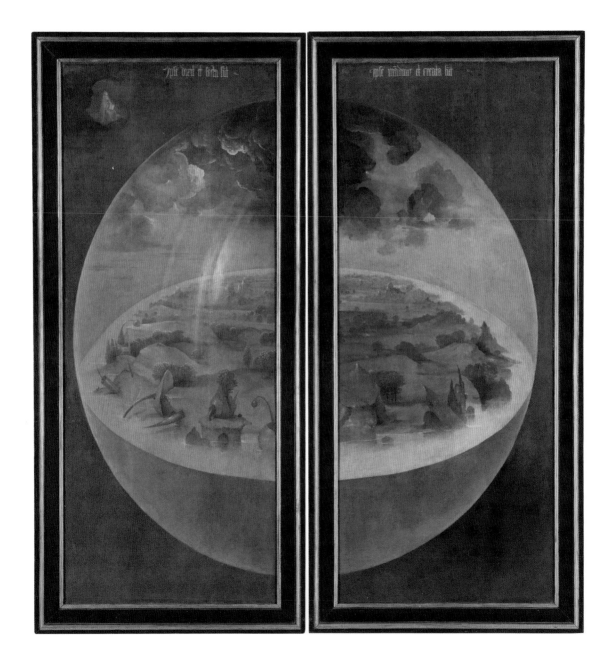

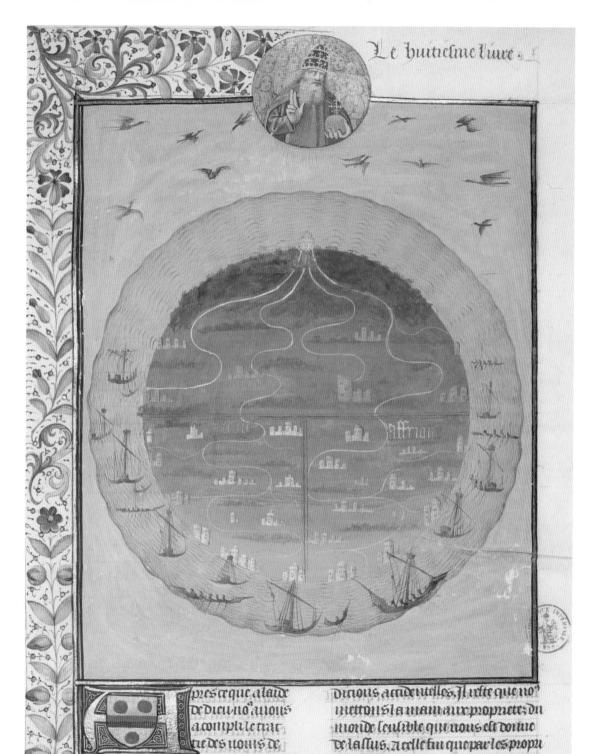

pres ce que a laide
de dieu no' auions
accompli le trac
te des noms de

dicions accidentelles, il reste que no°
mettons la main aux proprietes du
monde sensible qui nous est donne
de lassus. A celle fin que par les propri

◁◁ *Nyx series* #*60002* by Albarrán Cabrera (Anna Cabrera and Ángel Albarrán, both Spanish, b. 1969), pigments, gampi paper, and gold leaf, 2018

▽ *Genesis II* by Franz Marc (German, 1880–1916), color woodcut, 1914

Kinship with all creatures of the earth,
sky, and water was a real and active principle.
In the animal and bird world there existed a
brotherly feeling that kept us safe among them. . . .
The animals had rights—the right of man's protection,
the right to live, the right to multiply, the right to freedom,
and the right to man's indebtedness. This concept of
life and its relations filled us with the joy and mystery
of living; it gave us reverence for all life; it made a
place for all things in the scheme of existence
with equal importance to all.

—Chief Luther Standing Bear, *My People the Sioux*, 1928

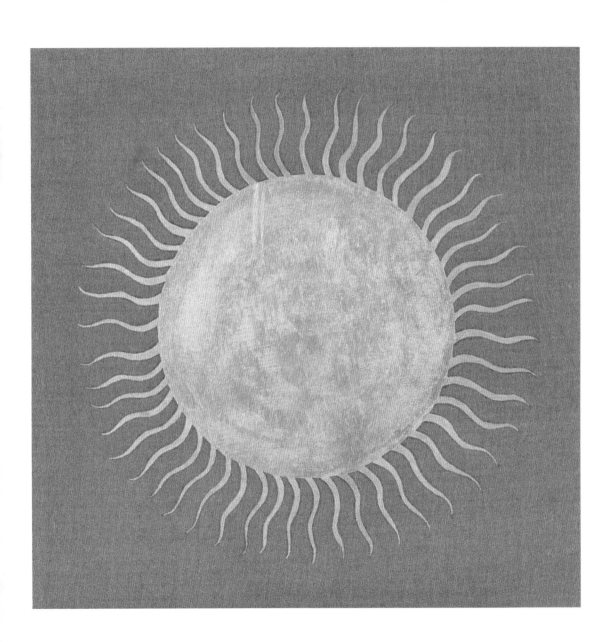

◁ *Genesis* by Jethro Buck (British, b. 1986), natural pigment on hemp paper, 2015

▽ *Keralan Sun* by Elisabeth Deane (British, b. 1985), gold leaf on handloom cloth (khadi) sourced in Kerala, India, 2019

34 ▽ Shamsa Medallion, artist unknown, opaque watercolor, gold, and black ink inlaid on laid paper, Iran, 16th or 17th century. A shamsa, meaning "little sun," is a detailed medallion design used in a variety of Islamic art contexts. It is often present in Islamic art motifs, such as the arabesque, and used to represent the unity of God.

▷ Kasuga Deer Mandala, artist unknown, hanging scroll, ink, color, and gold on silk, Japan, Nanbokuchō period to Muromachi period, mid-1300s to 1400s

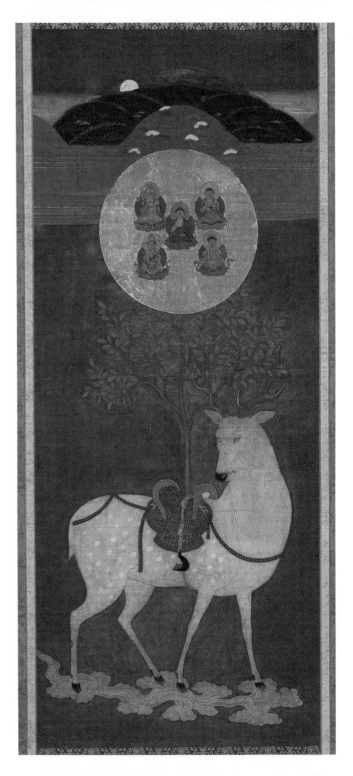

36 ▽ The Conference of the Birds by Habiballah of Sava (Iranian, active *c.* 1590–1610), folio 11r from a *Mantiq al-tair* by Farid al-Din 'Attar, ink, opaque watercolor, gold, and silver on paper, *c.* 1600. The Persian Sufi poet Farid al-Din 'Attar composed *Mantiq al-tair* in the 12th century. In this poem the birds of the world gather to choose the mythical Simurgh bird as king. However, the quest to find the Simurgh involves a daunting and arduous journey, reflecting the timeless, universal search for spiritual truth.

▽ *Baba Dev* by Bhuri Bai (Indian, b. 1968), acrylic on canvas, no date. Bhuri Bai (born in the district of Jahuba, which lies on the border between Madhya Pradesh and Gujarat) is of the Bhil community, India's largest tribal group, and a celebrated practitioner of Bhil art. Bai was the first internationally recognized artist from her community, creating works using acrylics and paper.

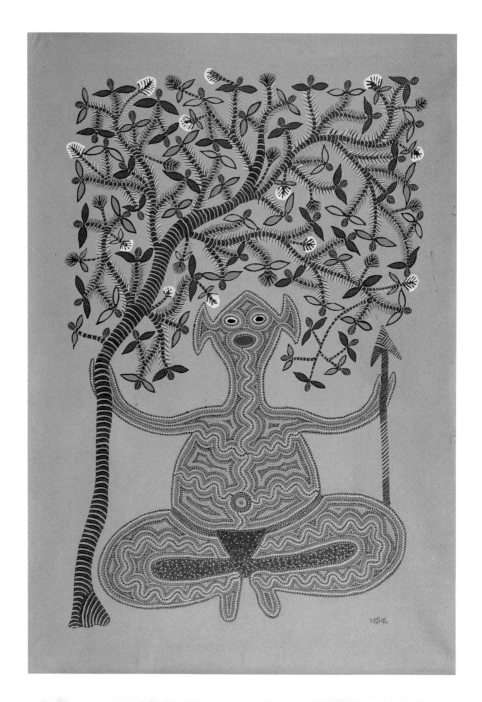

38 ▽ Plate 1, frontispiece, from *Songs of Innocence* by William Blake (British, 1757–1827), relief etching printed in brown with pen, black ink, and watercolor on moderately thick, slightly textured, cream wove paper, 1789

▷ Sampler by Ann Honilon, silk embroidery on wool foundation, embroidered in cross, tent, satin, stem, plush, and couching stitches on plain weave, *c.* 1760

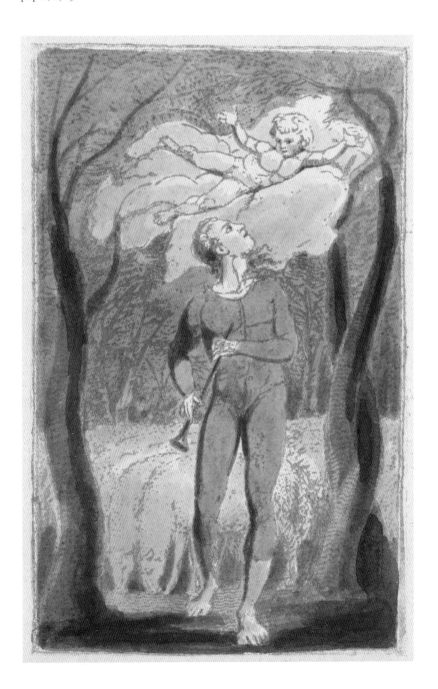

Immortal made what should we mind
so much as Immortalitie
of beings for a Heaven defign'd
what but a Heaven the care should be

Good is as visible as green.

—John Donne (1572–1631), "Community"

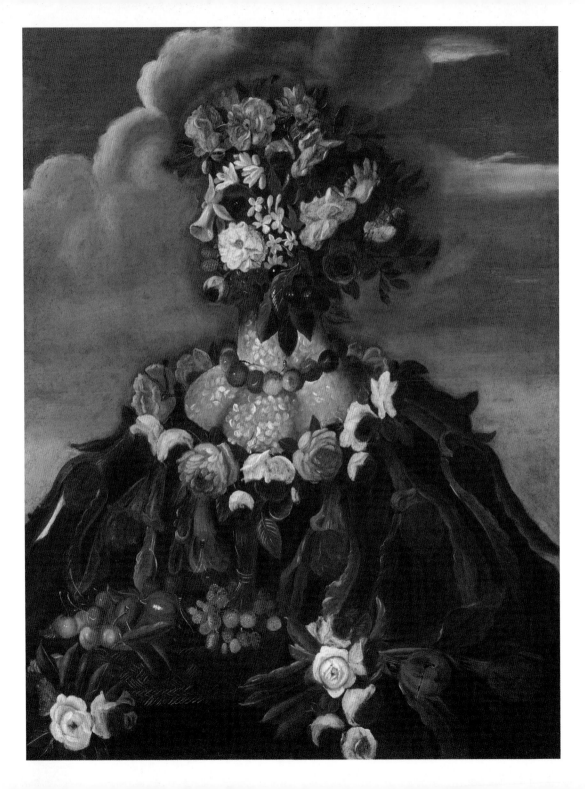

42 ◁◁ Spring, artist unknown, in style of Giuseppe
Arcimboldo (Italian, *c.* 1527–1593), oil on canvas,
c. 1580–1600

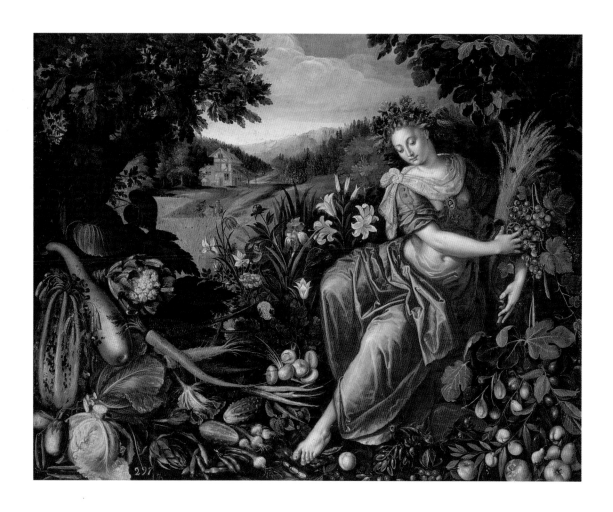

▽ *The Peaceable Kingdom* by Edward Hicks
(American, 1780–1849), oil on canvas, 1834

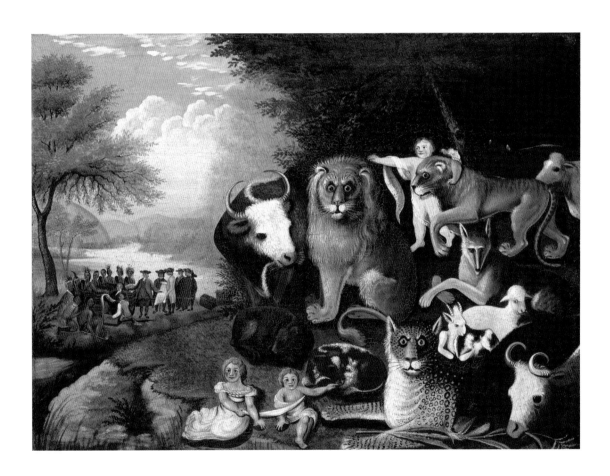

▽ *A Shepherd and his Flock under the Moon and Stars*
by Samuel Palmer (British, 1805–1881), brown wash,
gray wash, and white gouache with pen and brown ink
on very thick, slightly textured card, *c.* 1827

▽ Welcoming Descent of Amida (Amida Buddha/ Amida Raigō, the Buddha of Immeasurable Light and the Buddha of Limitless Life), artist unknown, hanging scroll, ink, color, and gold on silk, Kamakura period, Japan, 1300–33

▷ Celestial Dancer (Devata), artist unknown, sandstone, Madhya Pradesh, Central India, Chandela period, mid-11th century

▷▷ *Archangel Gabriel* by Ivan Meštrovic (Croatian, 1883–1962), marble, 1918

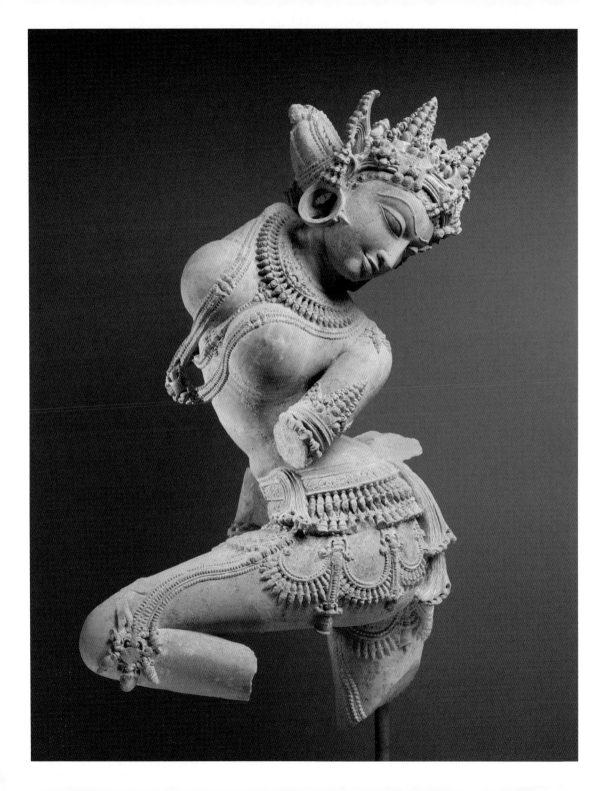

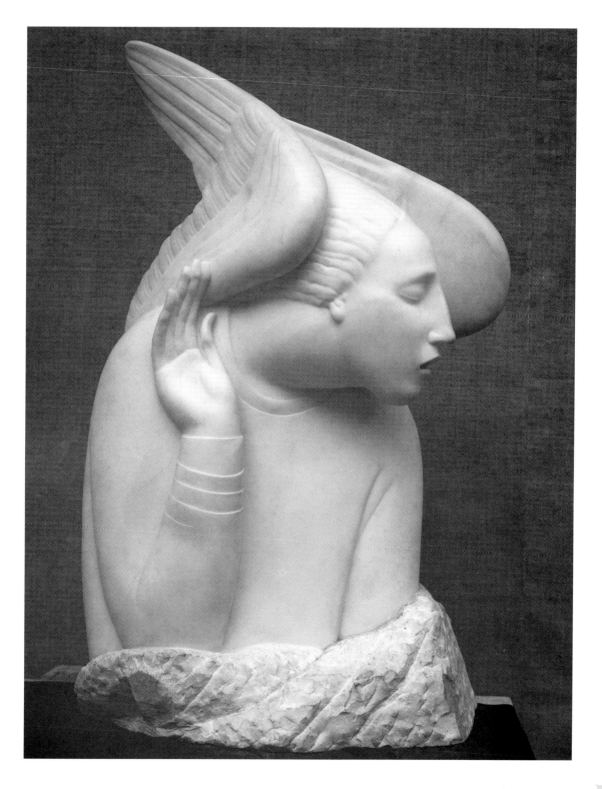

For Everything that lives is holy; for the Source of Life
Descends to be a Weeping Babe;
For the Earthworm renews the moisture of the sandy plain.

—William Blake, "The Song of Enitharmon over Los,"
from the unfinished *The Four Zoas*, 1796–1802

Fall

My silences had not protected me.
Your silence will not protect you.

—Audre Lorde, *The Cancer Journals*, 1980

▽ *L'Illusion, soeur d'icare* by Auguste Rodin (French, 1840–1917), marble, 1894–96, photograph by Eugène Druet (French, 1868–1917), gelatin silver print, 1896–1903

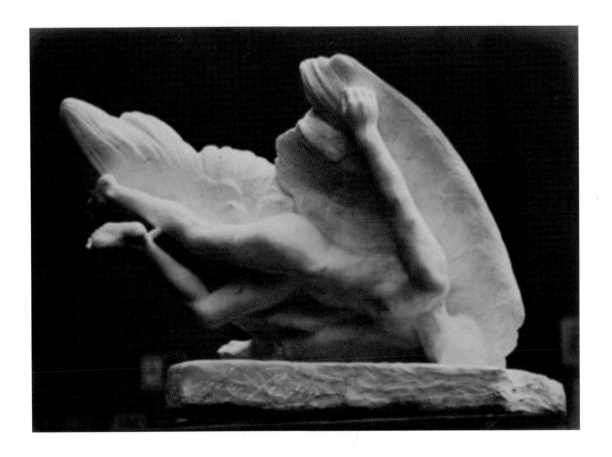

▽ *The Black Idol (Resistance)* by František Kupka (Czech, 1871–1957), aquatint, paper, 1903

▷ Punishments of Hell, published by Anant Shivaji Desai, Motibazar, Mumbai (Karla Lonavla: Ravi Varma Press), chromolithograph, pre-1945

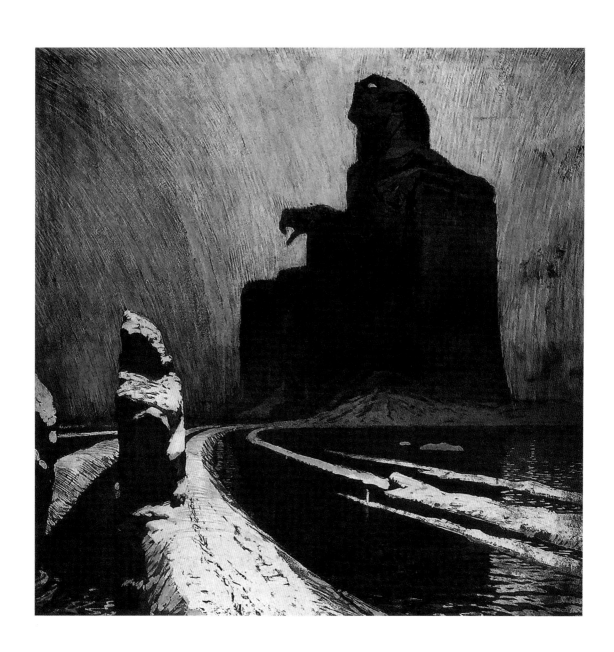

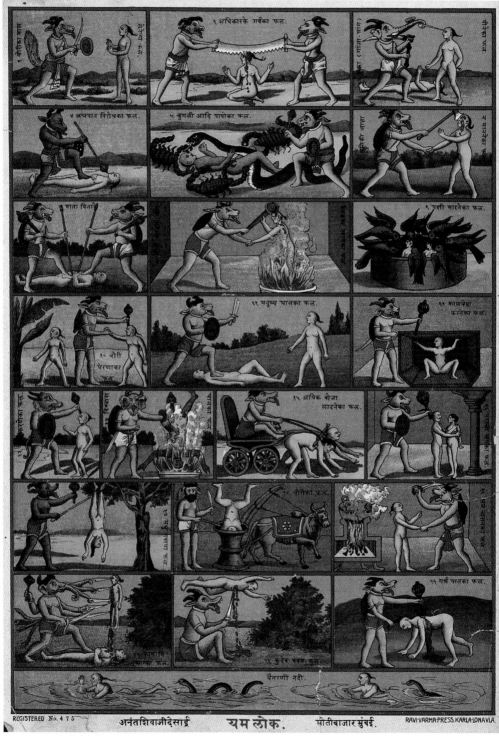

अनंतशिवाजीदेसाई **यम लोक.** मोतीबाजार मुंबई.

RAVI-VARMA-PRESS-KARLA-LONAVLA.

◁ The Prince of the Sinister, artist unknown, from *Compendium rarissimum totius Artis Magicae sistematisatae per celeberrimos Artis hujus Magistros*, *c.* 1775

▽ Hell by Colins Chadewe, from *Apocalypse de S. Jean*, manuscript, French, 1313

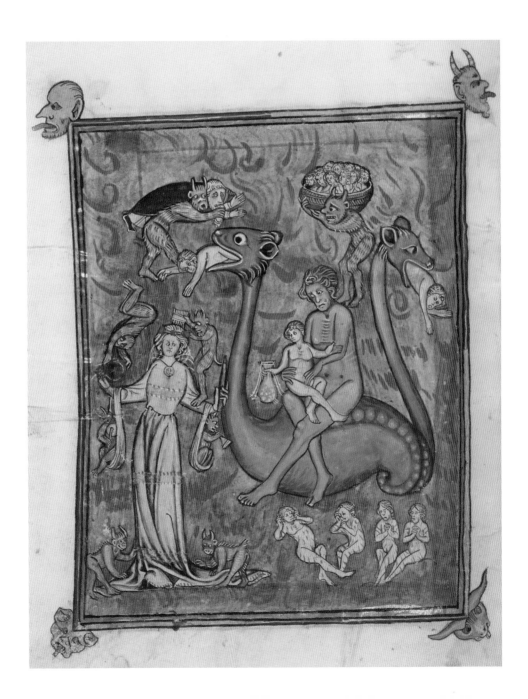

▽ Kings of the East, West, South, North from *Clavis Inferni sive Magia alba et nigra approbata* Metratona by M. L. Cyprianus, 18th century. From the *Clavis Inferni*, or *Key of Hell*, a text on black magic written in several languages, partly in code. It was said to be associated with the Black School at Wittenberg, an alleged institution for the study of arcane practices. The Four Kings represent both the cardinal points of the compass and four stages of spiritual transformation in the alchemical magnum opus.

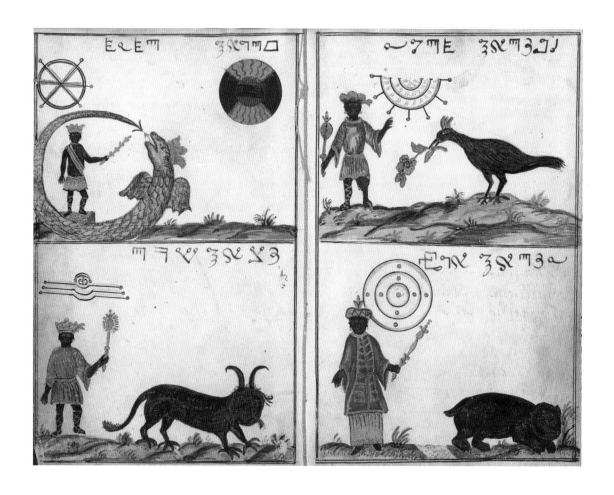

Christopher Columbus landed first
in the New World at the island of
San Salvador, and after praising God
enquired urgently for gold.

—C. L. R. James, *The Black Jacobins*, 1938

The worst is not
So long as we can say "This is the worst."

—William Shakespeare, *King Lear*, 1605–06

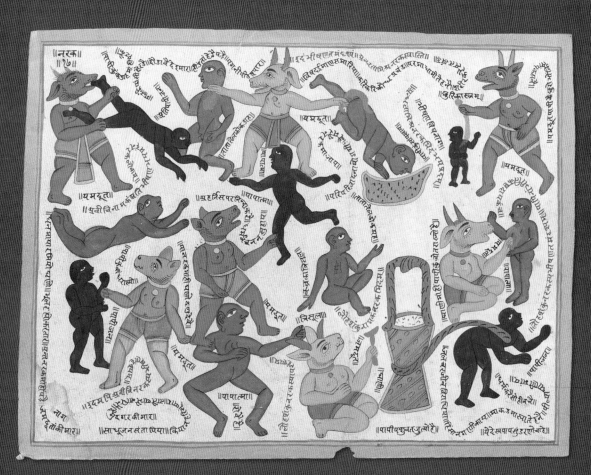

◁ *Many Lives Lived #75* by Kalu Ram (Indian, active from early 1960s, d. 2010), gouache on paper, 1970s

▽ Wild man or monster born on the borders of England and Normandy, from the manuscript *Histoires prodigieuses* by Pierre Boaistuau (French, 1517–66), presented to Elizabeth I, Queen of England, in 1560

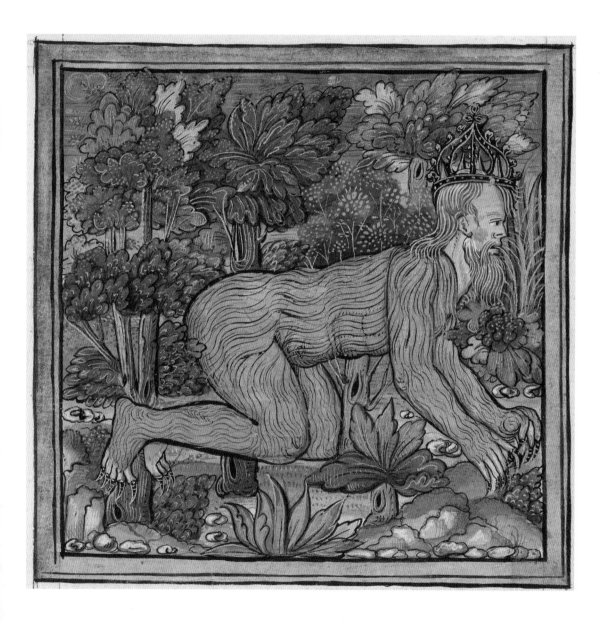

▽ A crowned fairy king seated on a hedgehog drawn by a young girl holding a giant daisy, accompanied by dancing fairies by Charles Altamont Doyle (British, 1832–93), watercolor, 19th century. Lettering on the reverse of the image reads "The fate of fairies is not always enviable."

▷ Kali Dancing on Siva by unknown Indian artist, watercolor on paper, c. 1890

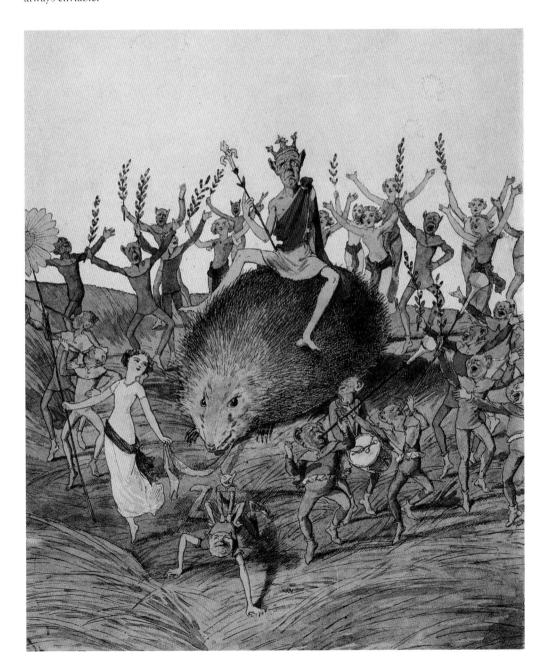

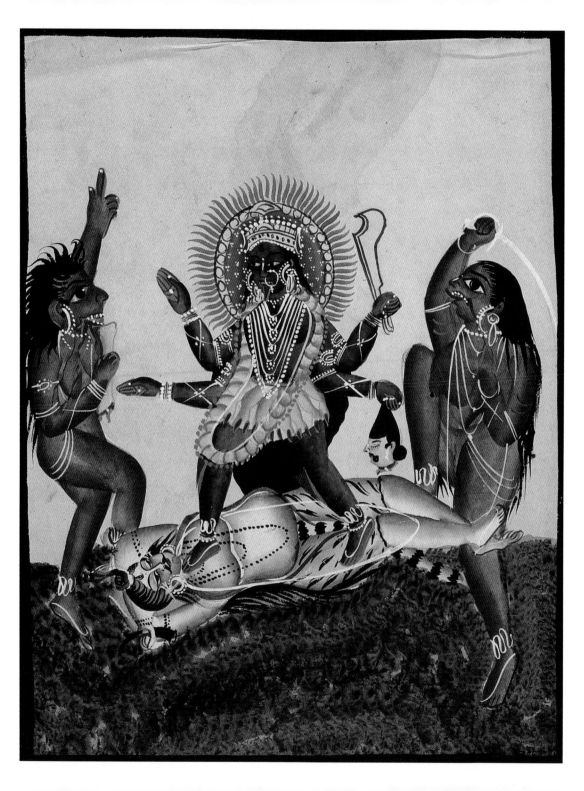

▽ Portents of Death and Destruction, artist and place
of creation unknown, gouache, possibly from a
15th-century manuscript

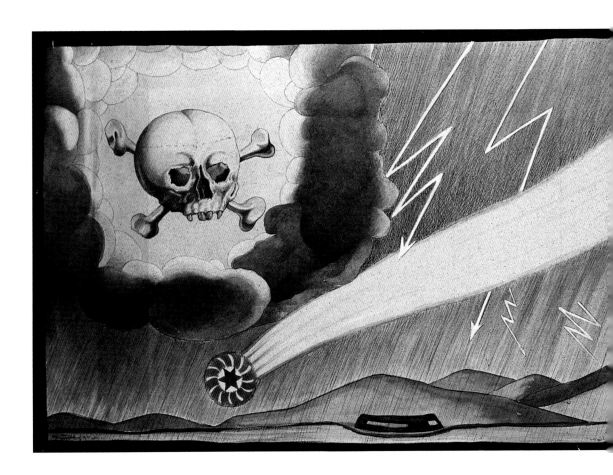

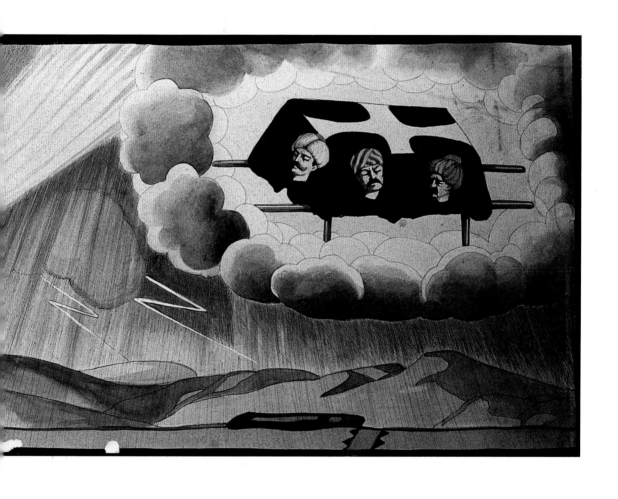

66 ▽ *The Destruction of the Pharaoh's Host* by John Martin (English, 1789–1854), watercolor and oil paint with brown ink and scraping out on paper, 1836

▷ *The Flood of Noah (Genesis 7:11–24)* by William de Brailes (British, active *c*. 1230–60), *c*. 1250

▷▷ *Fable of the Dog and the Prey* by Paul de Vos (Flemish, 1591/95–1678), oil on canvas, *c*. 1636–38. Based on one of Aesop's fables in which a dog carrying meat in his mouth for a later meal spots his reflection in a brook. Believing he has seen another dog holding an extra meal, he opens his jaws to take it too and drops his own in the water. Moral: "If you covet all, you may lose all."

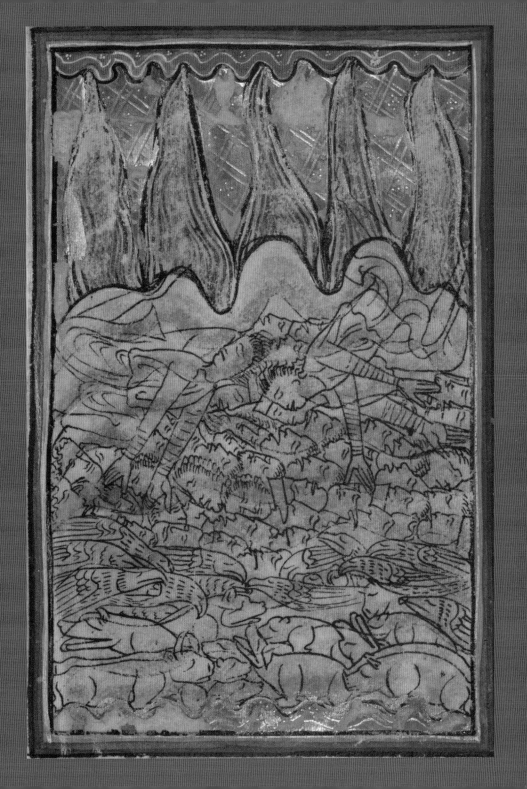

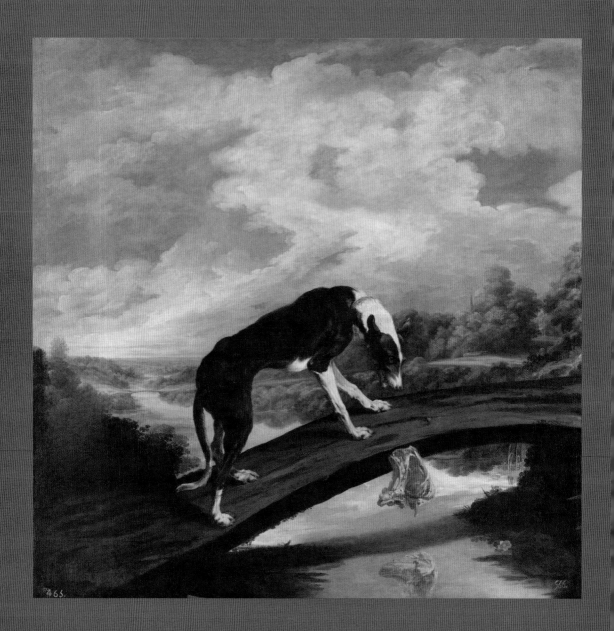

465.

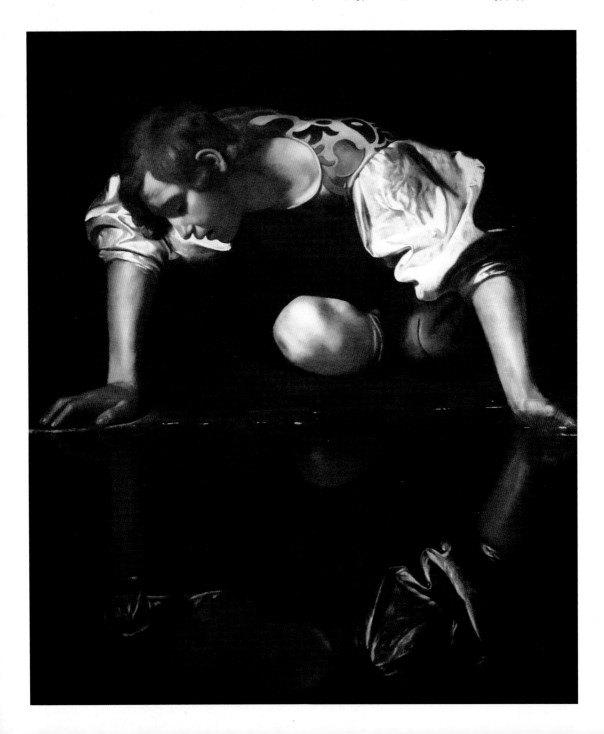

▽ The Tree of Intemperance, showing diseases and vices caused by alcohol, artist unknown, colored lithograph, published by Currier & Ives, New York, 19th century

THE TREE OF DEATH.

But a corrupt tree bringeth forth evil fruit. St Mat VII 17 Cut it down, why cumbereth it the ground ? St Luke XII. 7

▽ Wheel of Fortune from a manuscript by Brother
Gilles Romain, de l'ordre des freres hermites de saint
Augustin, France, c. 1501–20

▷ *Allegory of Fortune* by Salvator Rosa (Italian,
1615–73), oil on canvas, c. 1658–59

▷▷ Yama Holding the Wheel of Life, artist unknown,
distemper painting, no date. Yama is the Hindu god of
death and lord of the underworld.

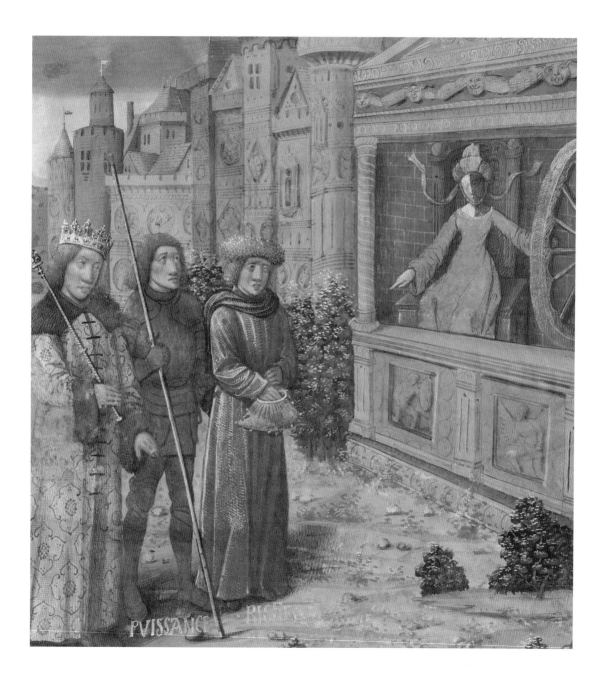

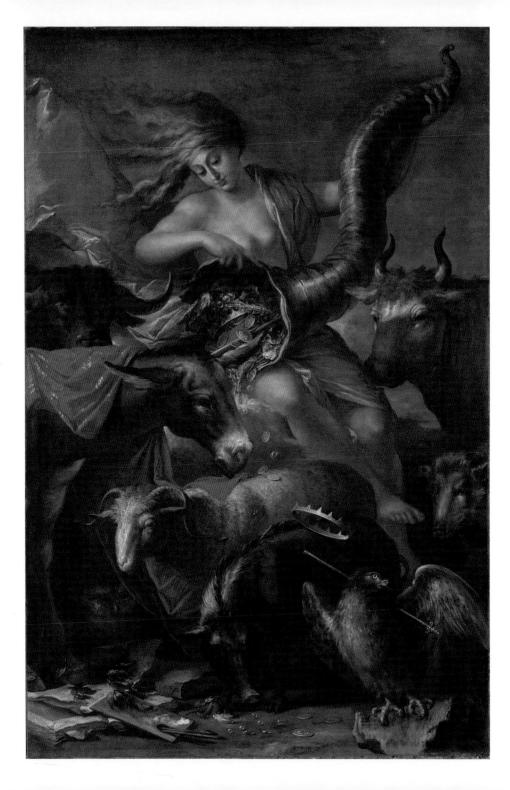

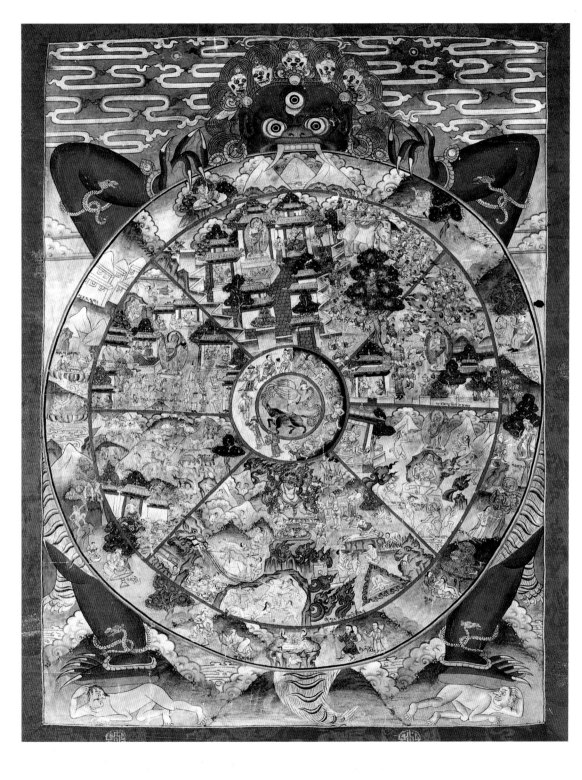

Every single empire in its official discourse
has said that it is not like all the others, that
its circumstances are special, that it has a mission
to enlighten, civilize, bring order and democracy,
and that it uses force only as a last resort.
And, sadder still, there always is a chorus of willing
intellectuals to say calming words about benign
or altruistic empires, as if one shouldn't trust the
evidence of one's eyes watching the destruction
and the misery and death brought by
the latest mission civilizatrice.

—Edward Said, preface to the 2003 edition of *Orientalism*, 1978

Connections

In the Nyul Nyul tribe there were two old men, elders, bush doctors, grandfathers of our tribe. They were professors of the land and knew what it held. It was them that instructed us men in land caring and it was our job to keep the country safe from fire and make sure that the trees were healthy and fruited regularly. Everything relied on aboriginal land management. Women also had their elders, grandmothers, our medicine women. The girls and boys were taught when the time was right for them to learn. Women were the main harvesters, but everyone worked together and pitched in to make sure we had everything we needed to survive each day. This is how we survived so long in this country. Everyone has a role to play and everyone fulfilled their purpose. We were happy and satisfied with what we have and what we've got. White people, such as the police or priests from the Mission, said to our old people, "You people are useless and hopeless people and never did anything with this land. You don't deserve to have this country." This broke my old people's heart. This country meant everything to them. Our old, old people kept this country clean and pure as the time it was created and that was what was important to us, that was the job we were given by our great creator. We, the Nyul Nyul People!

—Bruno Dann, Winawarl, Indigenous artist and Indigenous landcare and culture specialist, chairperson of Manowan Aboriginal Corporation

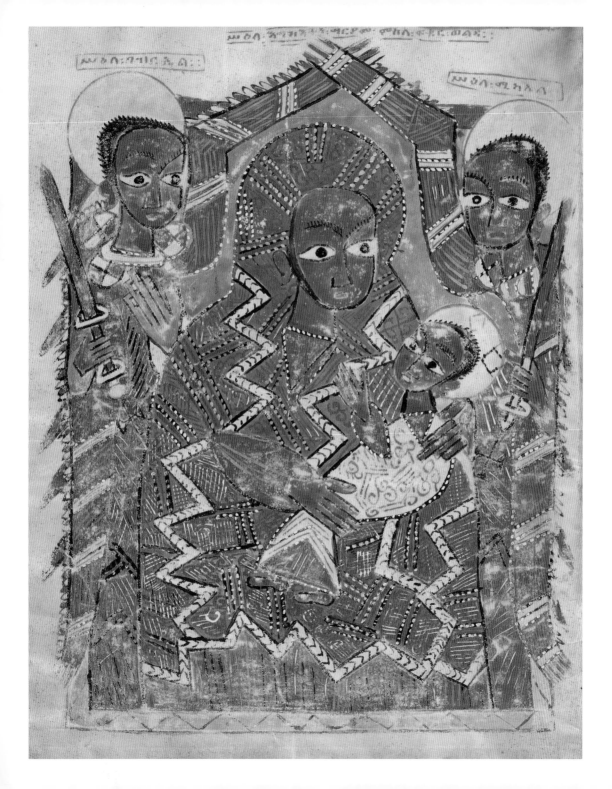

◁◁ The Virgin and Child with the Archangels Michael and Gabriel, artist unknown, tempera on parchment, Ethiopia, *c*. 1504–05

▽ *Virgen de Belén* (*Virgin of Bethlehem*) by unknown artist from Cuzco School, oil on canvas, Peru, *c*. 1700–20

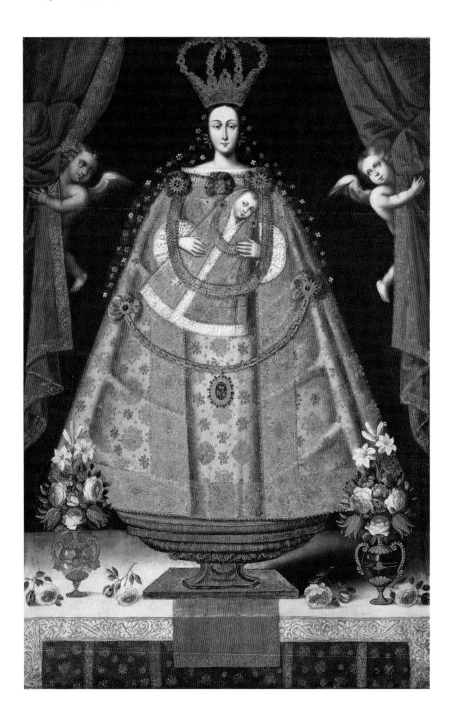

▽ Female Figure by Goulandris Master (Greek, active *c.* 2500–2400 BCE), marble, Early Cycladic III, *c.* 2500–2400 BCE

▷ Akbar With Lion and Calf by Govardhan (Indian, active *c.* 1596–1645), folio from the *Shah Jahan Album*, ink, opaque watercolor, and gold on paper, *c.* 1630. Abu'l-Fath Jalal-ud-din Muhammad Akbar was a Mughal emperor, reigning from 1556 to 1605.

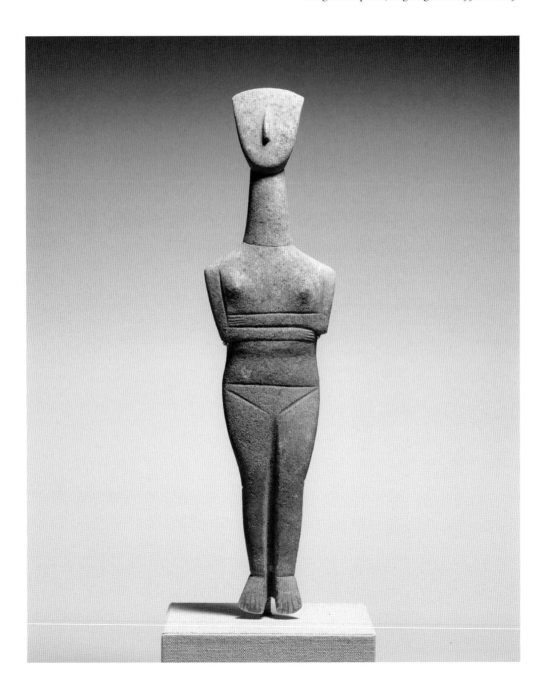

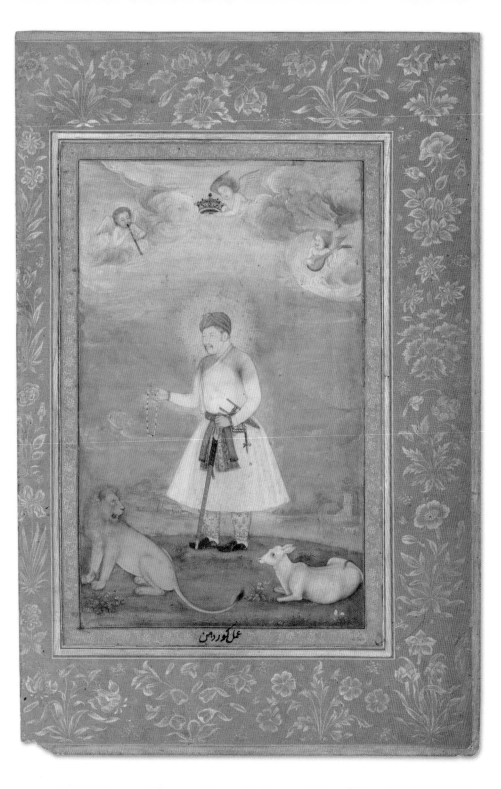

عمل گور دهن

84　▽ The Ten Madavidyas (Mahavidyas), artist unknown, chromolithograph, published by The Calcutta Art Studio, no date. The Mahavidya represent the ten aspects of the Supreme Goddess Devi in Hinduism. The goddesses depicted are Kali, Tara, Shodashi, Bhuvaneshvari, Bhairavi, Chhinnamasta, Dhumavati, Bagalamukhi, Matangi and Kamala.

▷ *A Gathering of Holy Men of Different Faiths* by Mir Kalan Khan (Indian, active *c.* 1730–75), opaque watercolor and gold on paper, *c.* 1770–75

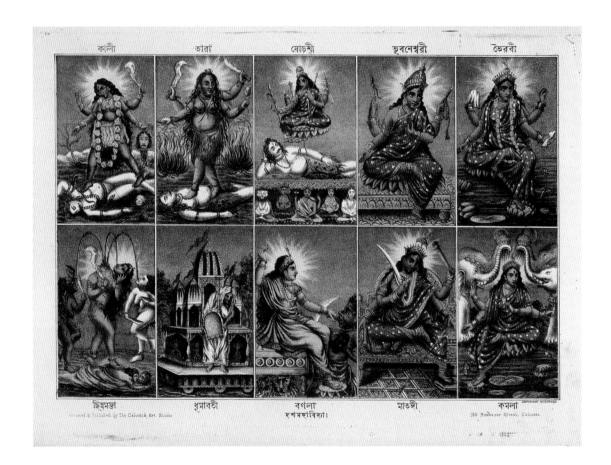

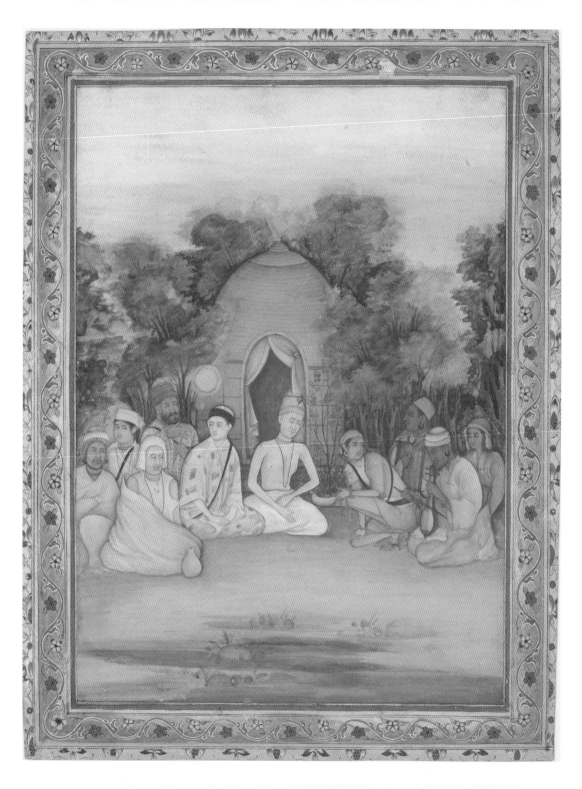

▽ Tantric Figure, artist unknown, Indian depiction of the chakra and nadi in the Śaiva tradition, no date

▷ Ritual Dish (*daveniyaqona*), artist unknown, wood (vesi), Fiji, early 19th century

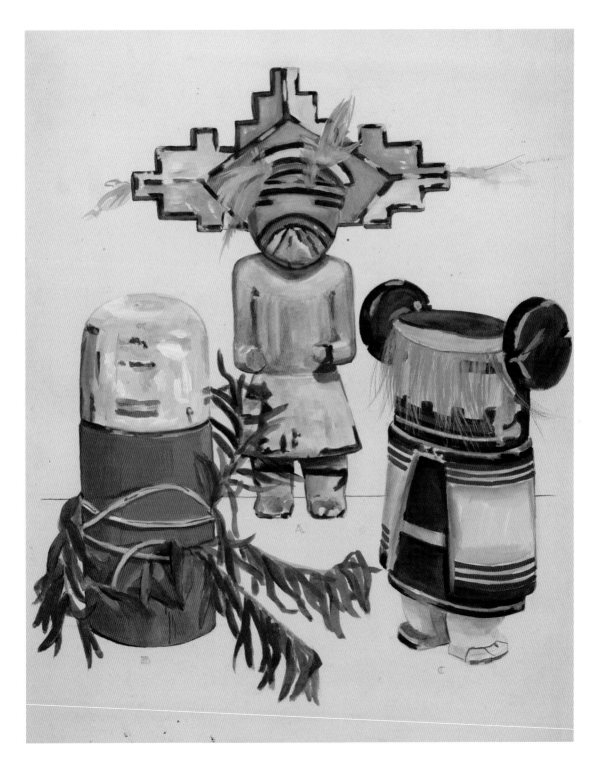

◁ *Kachina Doll* by Jane Iverson (American, 1910–97), watercolor, graphite, and gouache on paper, *c.* 1935–42. A kachina is a spirit in the religion of the Pueblo Native American culture. They are believed to visit villages in spring and summer, and are capable of using their

power for human benefit. Those who are given dolls are responsible for their care.

▽ *Kybele figure* 2 by Ceren Muftuoglu (born in Turkey, living in the United States), earthenware and glaze, 2018

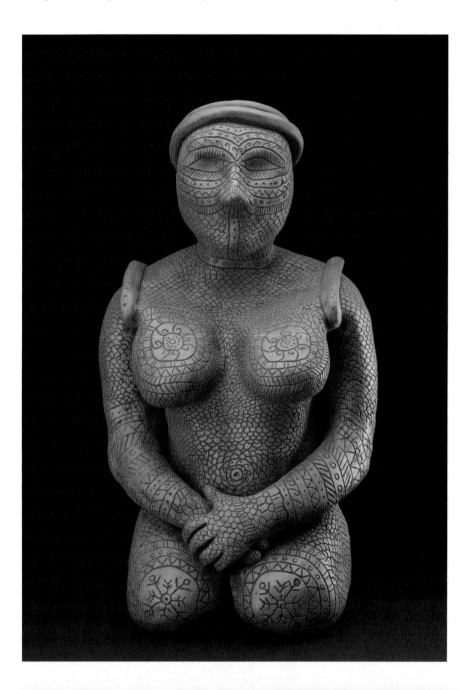

90 ▽ Dance Cape, known as a Button Blanket, by unknown Tsimshian artist, wool trade cloth, shell buttons, British Columbia, Canada, c. 1850–60

▷ A "Yebichai Sweat" Navajo Medicine Ceremony: Three Navajos in Ceremonial Dress with Faces Masked by Edward S. Curtis (American, 1868–1952), matt, brown-toned silver gelatin print, 1904

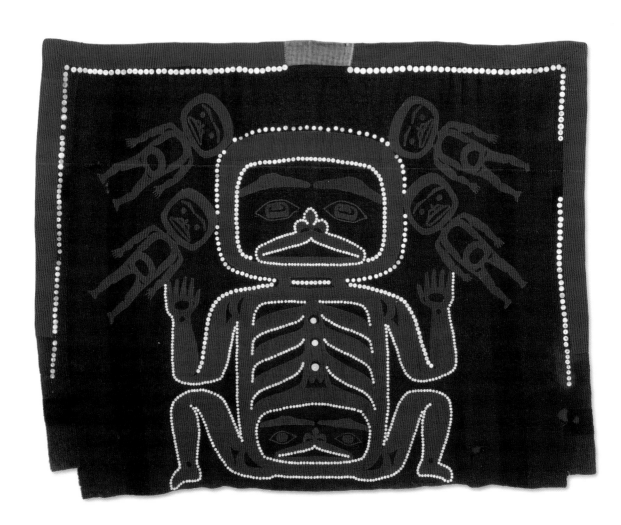

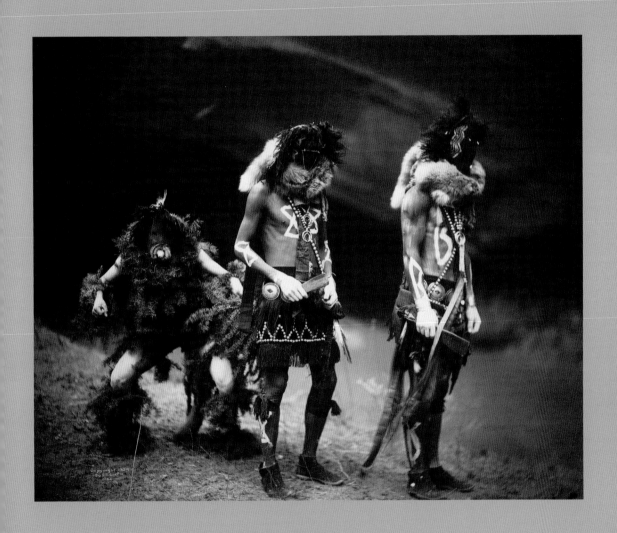

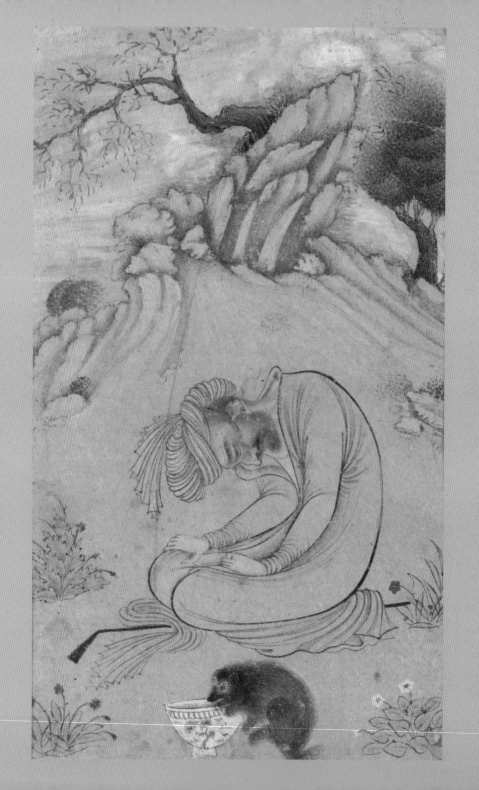

◁ Ascetic in Meditation, attributed to Mu'in Musavvir (Iranian, *c.* 1610–93), ink and opaque watercolor on paper, 17th century

▽ Textile Doll Found in a Tomb, artist unknown, cotton, wool, and wood, Peru, 1000–1450

93

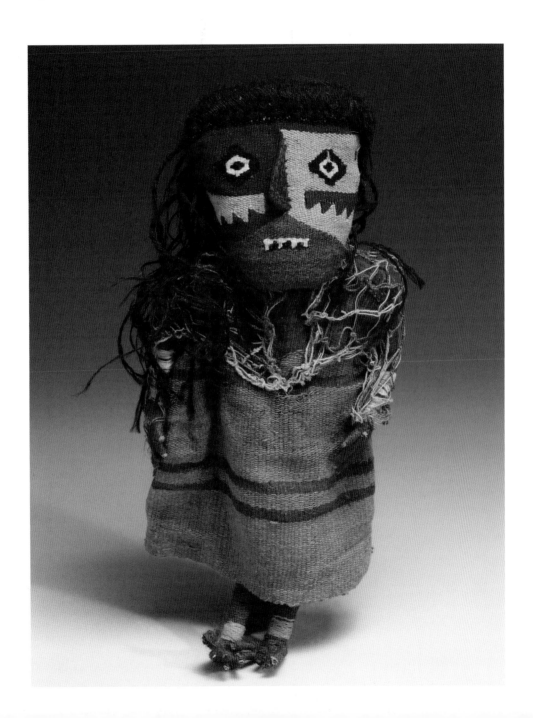

▽ [The wasp with buzzing whir will chase them all away], Edward S. Curtis (American, 1868–1952), gelatin silver print, 1910–14

▷ Dancing Dervishes, from a folio from *Divan of Hafiz*, attributed to Bihzad (Iranian, Herat, *c*. 1450–1535/6), opaque watercolor and gold on paper, Herat, Afghanistan, *c*. 1480

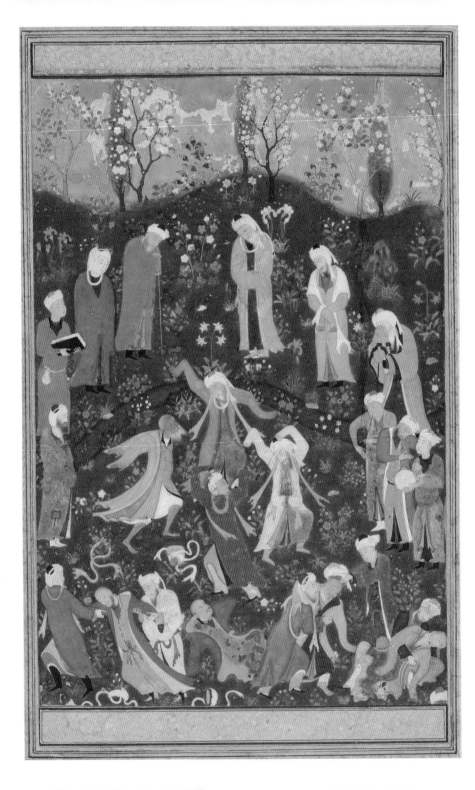

▽ Female Figure, artist unknown, clay, pigment, El Ma'mariya, Egypt, *c.* 3500–3400 BCE

▷ Illustration by Marjorie Cameron (American, 1922–95), from *Cameron: Songs for the Witch Woman* by John W. Parsons and Marjorie Cameron, black ink on paper, 1955

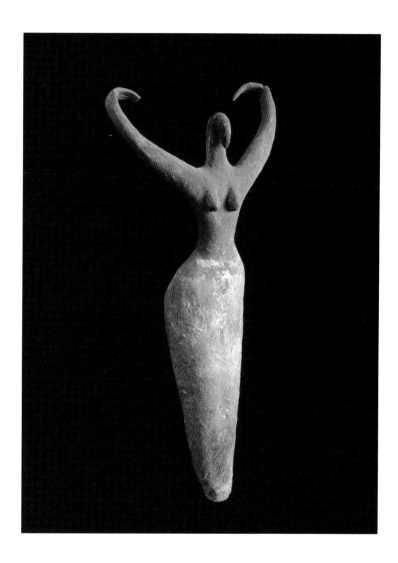

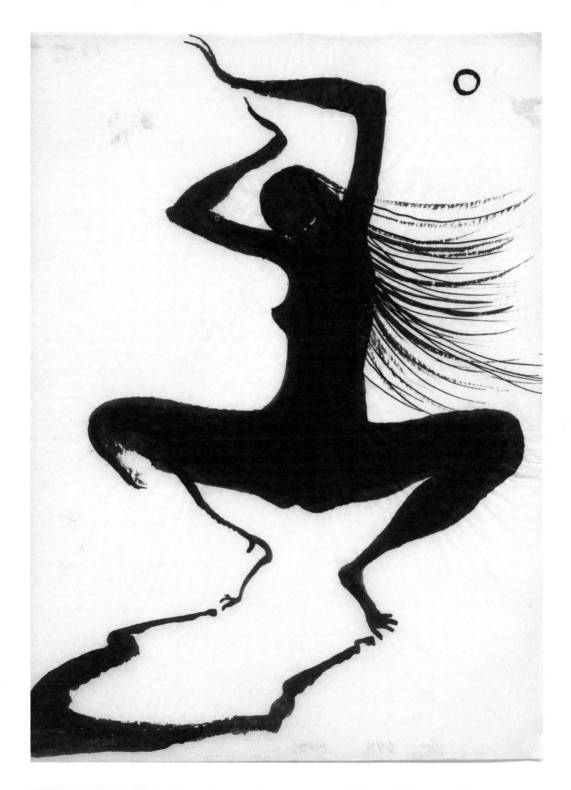

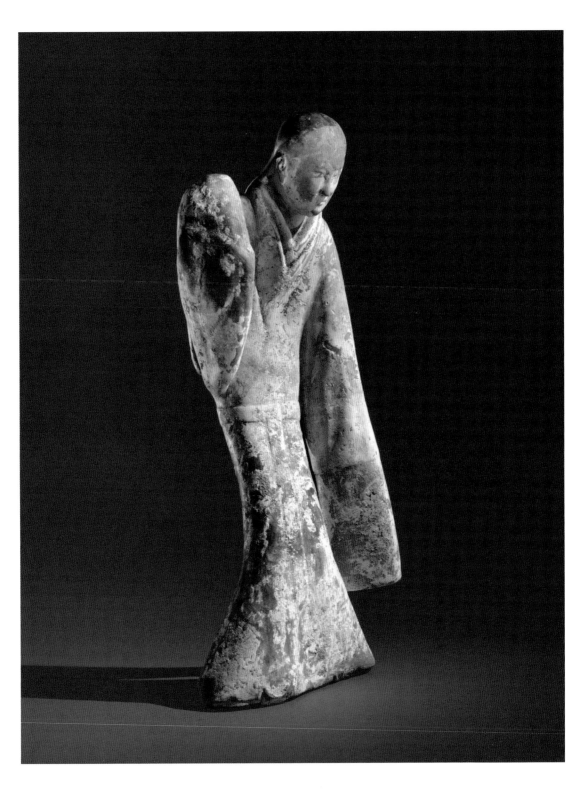

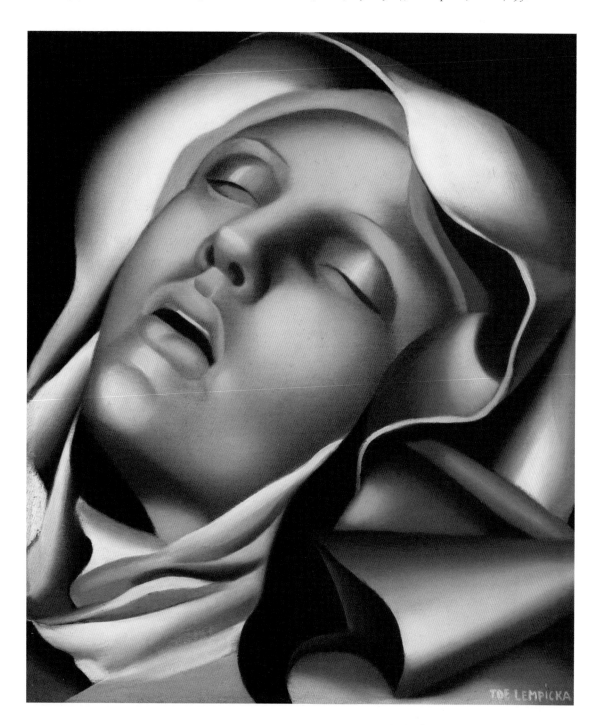

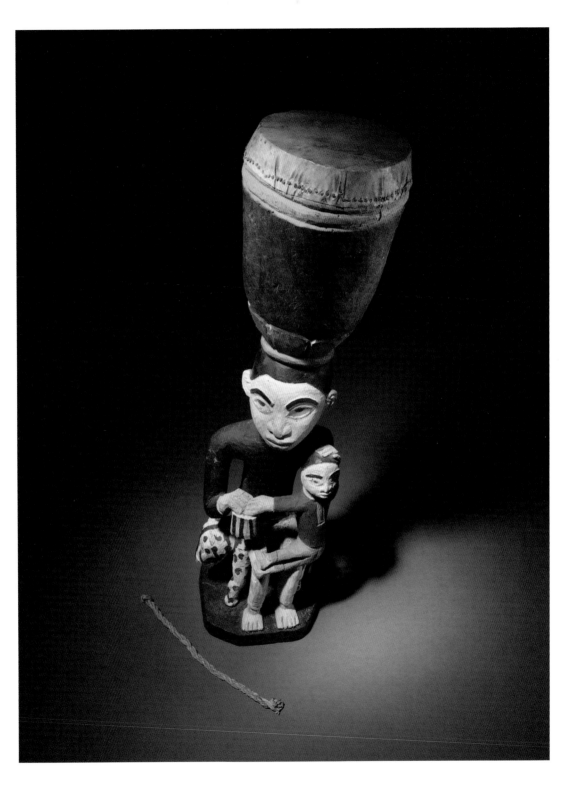

◁ Ngoma (drum) by unknown Vili or Yombe artist, wood, fiber, glass, Democratic Republic of the Congo, 19th century

▽ Bum-bemsue, a Sauk (Sac) or Fox chieftain, by Thomas Martin Easterly (American, 1809–82), daguerreotype with applied color, 1847. One of 11 such portraits, together considered to be among the first photographs ever taken of Native Americans.

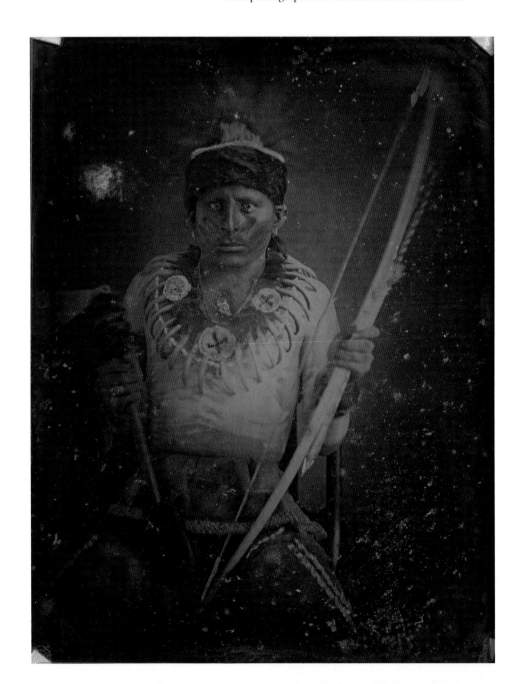

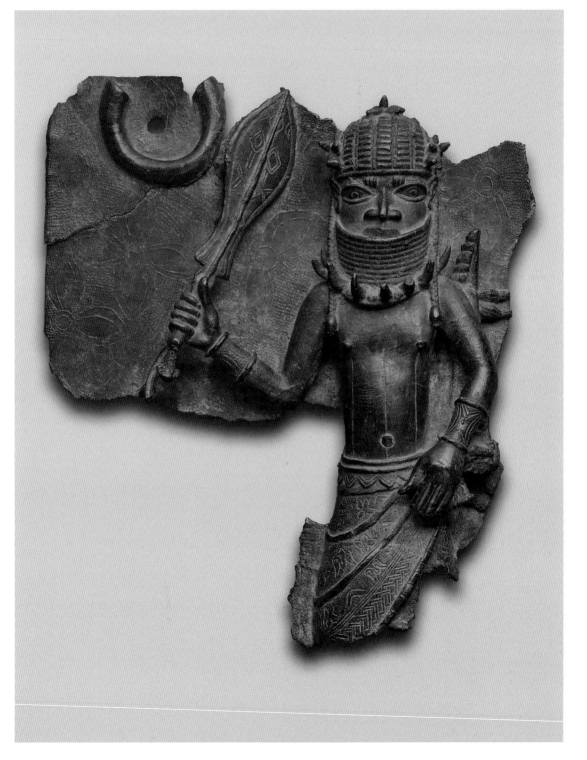

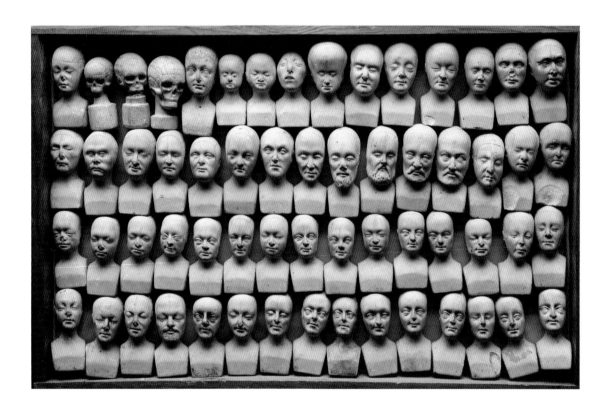

▽ *Dance to the Berdash* by George Catlin (American, 1796–1872), oil on canvas, 1835–37. The berdash was an annual dance, followed by a feast, in honor of a "berdash" or "two-spirit" individual—a young male who had taken on the habits, appearance, and fashion of a female within the Native American Sac and Fox Nations.

▷ Women Bathing Before an Architectural Panorama by Fayzullah (Indian, active *c.* 1730–65), opaque watercolor and gold on paper, *c.* 1765

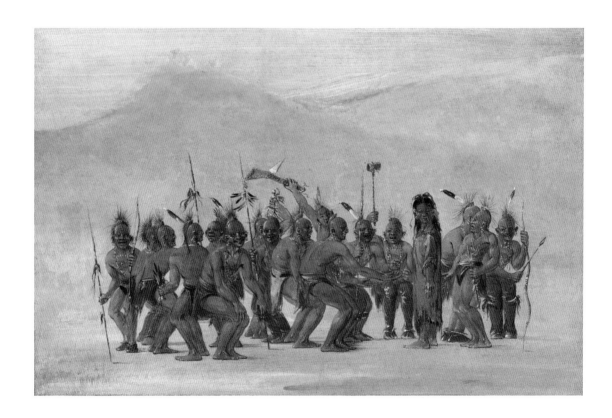

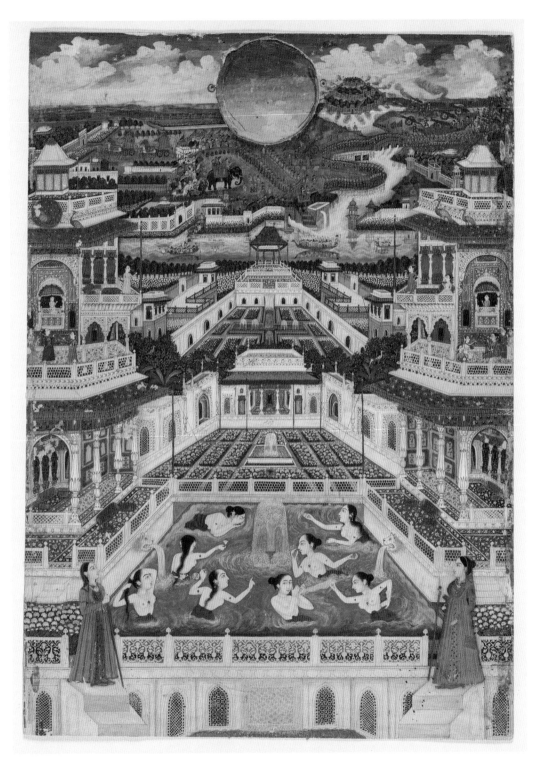

106 ▽ Funeral Ritual in a Garden, Tomb of Minnakht, original Upper Egypt, Thebes, *c.* 1479–25 BCE, facsimile painted by Charles K. Wilkinson, tempera on paper, 1921

▷ William Price of Llantrisant, in druidic costume, with goats, by Alfred Charles Hemming (Welsh, active *c.* 1904–33), oil on canvas, 1918. William Price (1800–93) was a famed Welsh doctor, nationalist, heretic, and archdruid. A flamboyant and radical figure, he avoided socks, primarily drank champagne, and was an outspoken Chartist, outstanding surgeon, pioneer of social health care, and passionate advocate of vegetarianism and animal welfare. His public cremation of his deceased infant son Iesu Grist (Jesus Christ), controversial at the time, set a precedent and paved the way for widespread acceptance and eventual legalization of cremation in the UK.

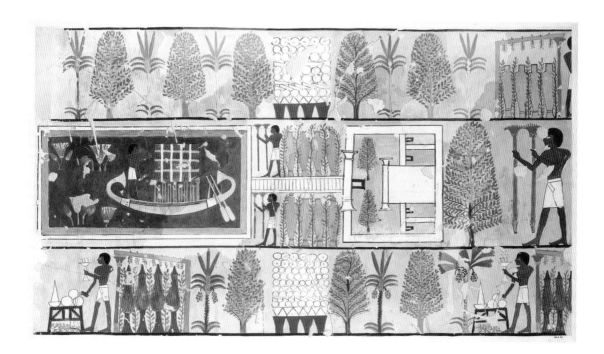

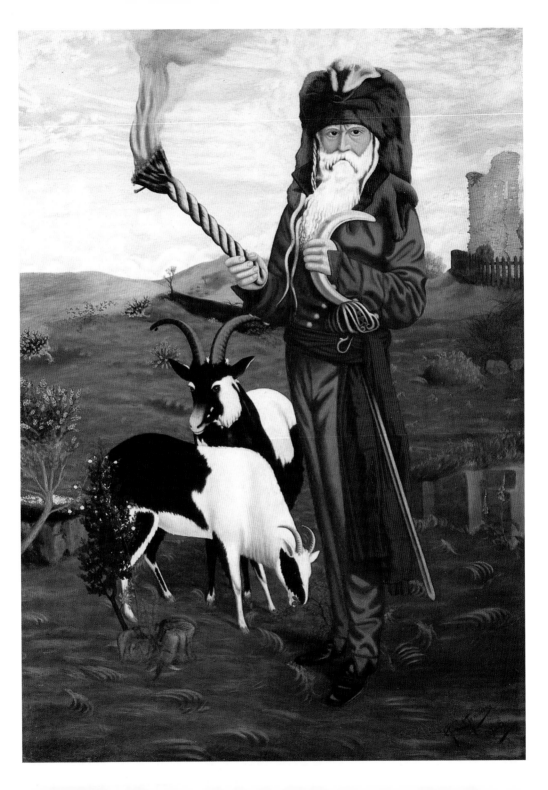

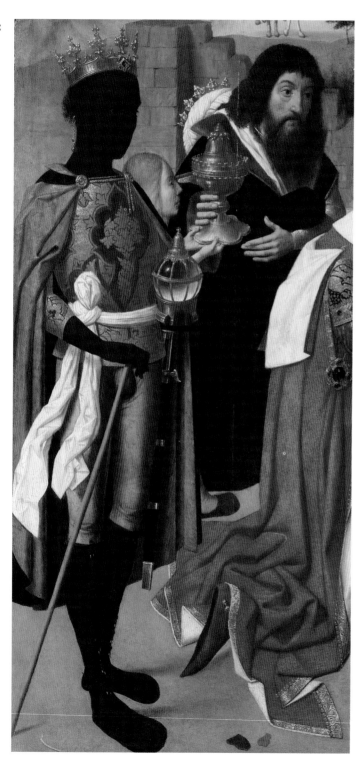

◁ Detail from *Adoration of the Magi* by Geertgen tot Sint Jans (Dutch, *c.* 1455/65 – *c.* 1485/95), oil on oak panel, *c.* 1480–85

▷ Two Women Embracing Each Other as One Holds a Glass and a Bottle, artist unknown, gouache, with pen and ink, India, 19th century

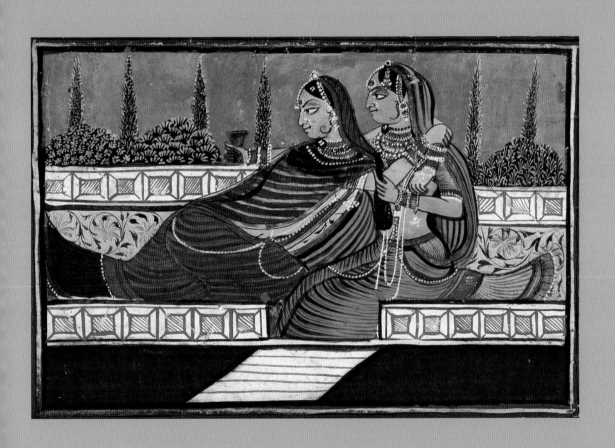

Love is the extremely difficult realisation
that something other than oneself is real.

—Iris Murdoch, "The Sublime and the Good," *Chicago Review*, vol. 13, no. 3, 1959

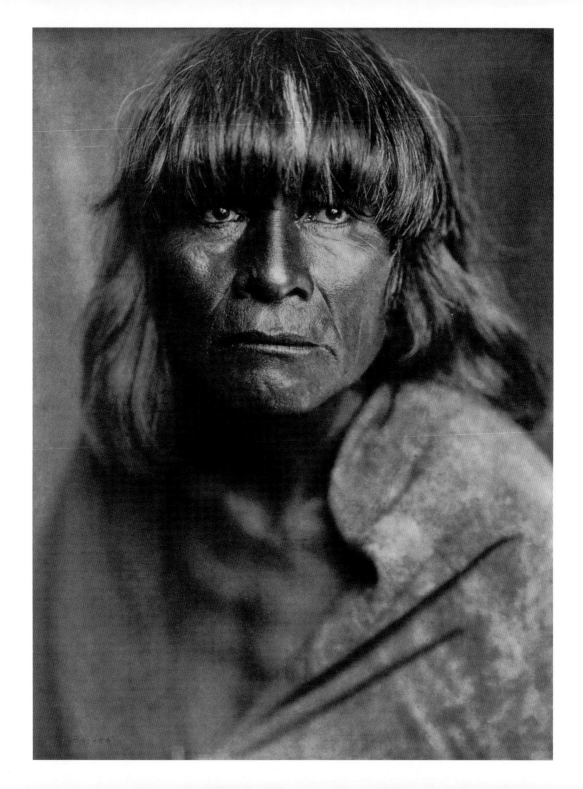

◁◁ *A Hopi Man* by Edward S. Curtis (American, 1868–1952), photogravure on vellum paper, 1921

▽ *The Sofa* by Henri de Toulouse-Lautrec (French, 1864–1901), oil on cardboard, *c.* 1894–96

▷ A Couple Holding Hands, photograph, no date

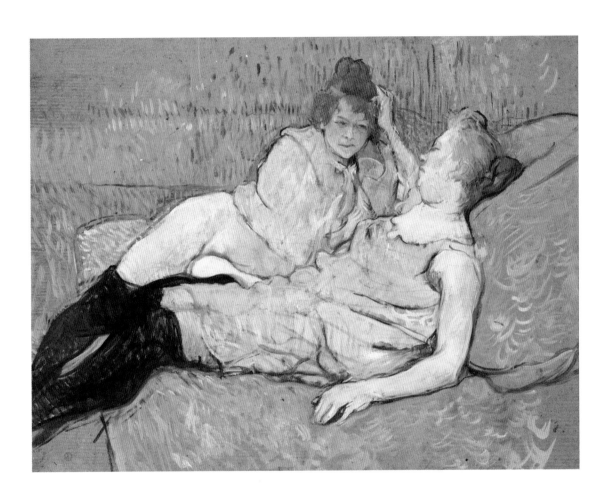

Your ever
Söllbalelssi

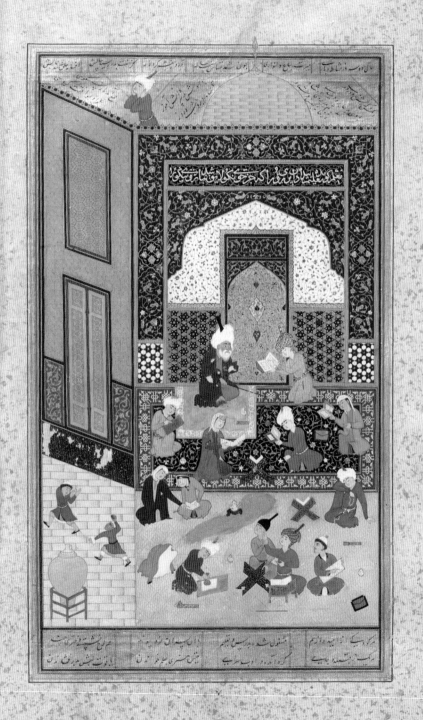

◁ Laila and Majnun in School by Shaikh Zada (Persian, first half of 16th century), folio 129 from *Khamsa* (*Quintet*) by 12th-century Persian Sunni Muslim poet Nizami Ganjari, ink, opaque watercolor, and gold on paper, present-day Afghanistan, 1524–25

▽ Market scene, historical depiction of urban activities, by Diego Rivera (Mexican, 1886–1957), fresco painting from the staircase of the Palacio Nacional, Zócalo, Mexico City, Mexico, 1930

▷▷ Comet, artist unknown, illustration from French satirical magazine *L'Assiette au beurre*, 1910

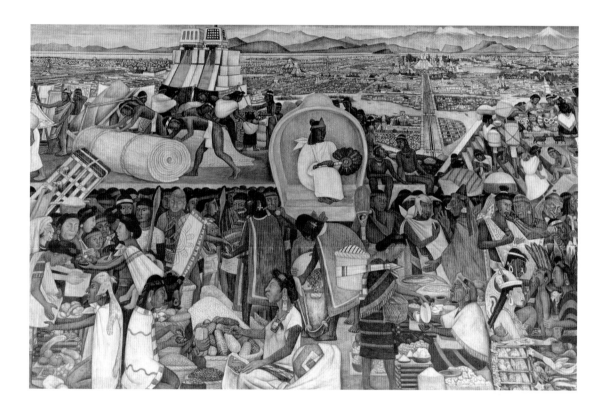

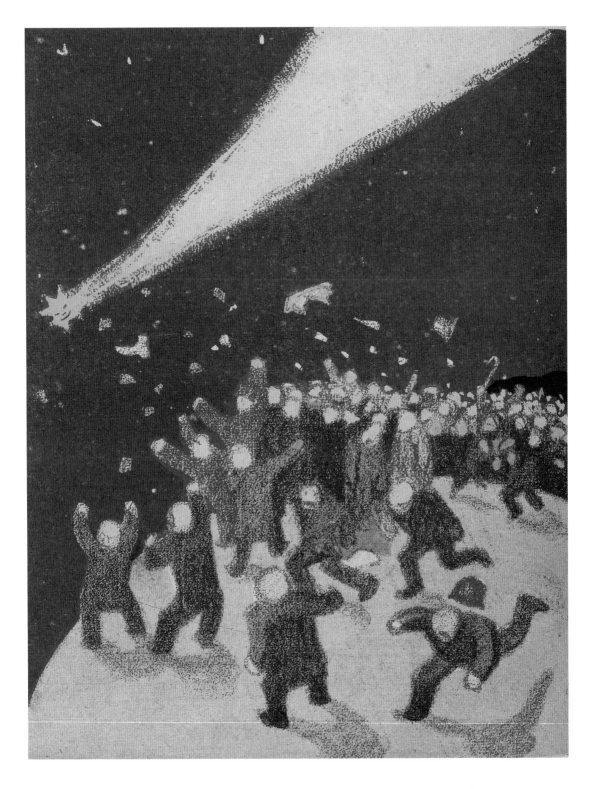

In the beginning of Time, the great Creator Reason, made the Earth to be a Common Treasury, to preserve Beasts, Birds, Fishes, and Man, the lord that was to govern this Creation; . . . but not one word was spoken in the beginning, that one branch of mankind should rule over another. . . . But . . . selfish imaginations . . . did set up one man to teach and rule over another; and thereby . . . Man was brought into bondage, and became a greater slave to such of his own kind, than the beasts of the field were to him. And hereupon the Earth . . . was hedged into enclosures by the teachers and rulers, and the others were made . . . Slaves.

— Gerrard Winstanley, *The True Levellers Standard Advanced: Or, The State of Community Opened, and Presented to the Sons of Men,* 1649

If there must be trouble, let it be in my day, that my child may have peace.

—Thomas Paine, *The American Crisis,* 1776–83

Loss

The concept of progress must be grounded in the idea of catastrophe. That things are "status quo" is the catastrophe. It is not an ever-present possibility, but what in each case is given. Thus hell is not something that awaits us, but this life here and now.

—Walter Benjamin (1892–1940), *The Arcades Project*, 1982

△ *Whetting the Scythe* by Käthe Kollwitz (German, 1867–1945), etching with tonal textures and engraving, printed in black on thick cream wove paper and overworked in parts with pencil, 1905

121

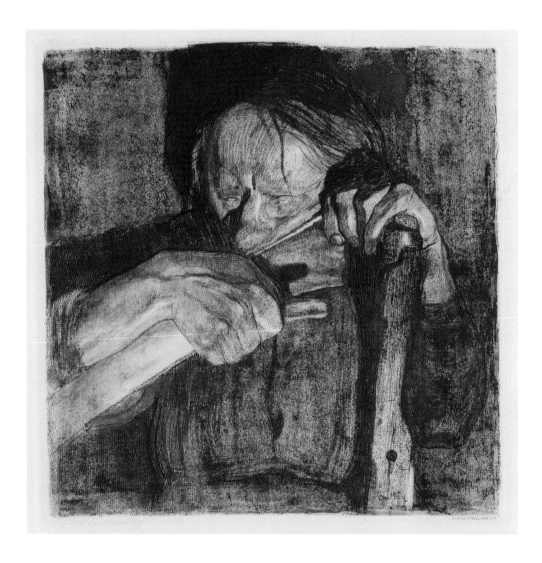

▽ *The Flatterers* by Pieter Brueghel the Younger
(Flemish, *c.* 1564–1638), oil on panel, *c.* 1592

◁ *An Enslaved African* by William James Muller (British, 1812–45), oil on paper laid onto panel, 1938

▽ A Young Girl with an Enslaved Servant and a Dog by Bartholomew Dandridge (British, 1691 – *c.* 1754), oil on canvas, *c.* 1725

125

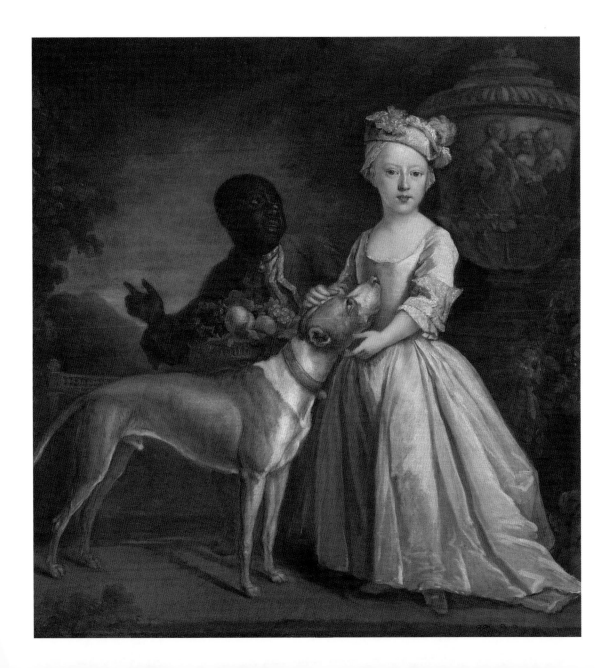

126 ▽ *The Triumph of Pulcinella* by Giovanni Domenico
Tiepolo (Italian, 1727–1804), oil on canvas, 1760–70

▽ *no world* from *An Unpeopled Land in Uncharted Waters* by Kara Walker (American, b. 1969), from a set of six etchings with aquatint, sugar-lift, spit-bite, and dry-point on paper, 2010

▷ (a) Untitled, (b) *Congo, Ibo, Mandingo, Togo*, and (c) *Grabbing, Snatching, Blink and You Be Gone*, from the series *Slave Coast* by Carrie Mae Weems (American, b. 1953), gelatin silver prints and offset lithograph, 1993

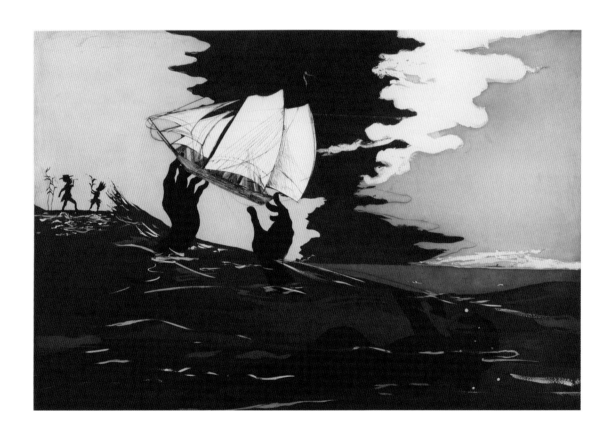

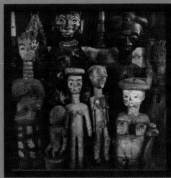

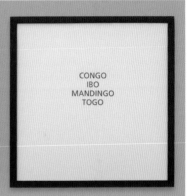

CONGO
IBO
MANDINGO
TOGO

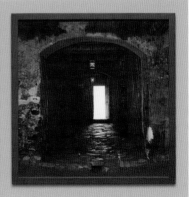

GRABBING
SNATCHING
BLINK
AND YOU
BE GONE

130 ▽ *Schwarze Frauen* (*The Black Women*) by Marianne
von Werefkin (Russian Swiss, 1860–1938), gouache on
cardboard, 1910

▷ (a) *The Second Class Carriage* and (b) *The First Class
Carriage*, by Honoré Daumier (French, 1808–79), water-
color, ink wash, and charcoal on slightly textured,
moderately thick, cream wove paper, 1864

▷▷ Pyramid of Capitalist System attributed to
Nedeljkovich, Brashich, and Kuharich, published in
Industrial Worker by The International Pub. Co.,
Cleveland, Ohio, 1911, based on a Russian flier, *c.* 1901

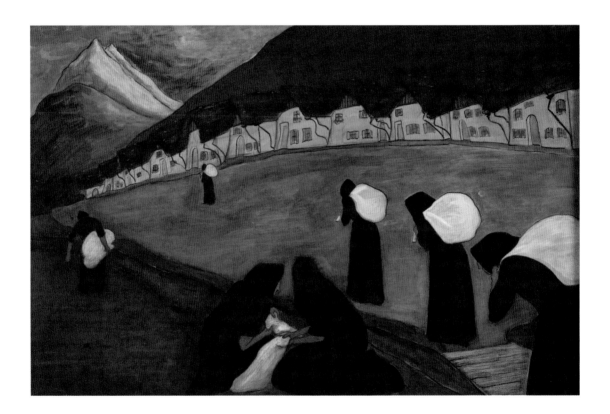

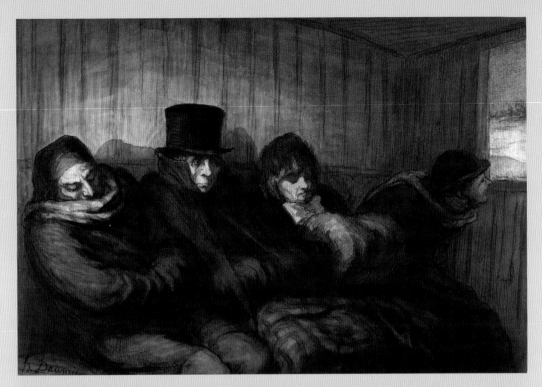
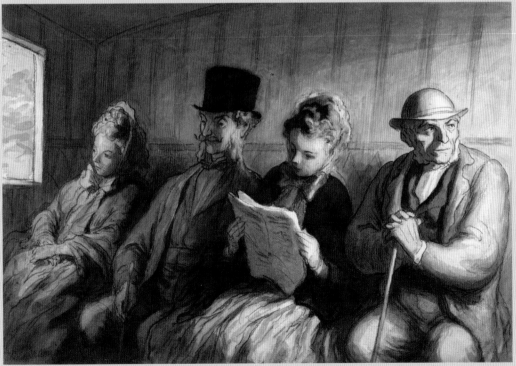

An election is coming. Universal peace is declared, and the foxes have a sincere interest in prolonging the lives of the poultry.

—George Eliot, *Felix Holt, the Radical*, 1866

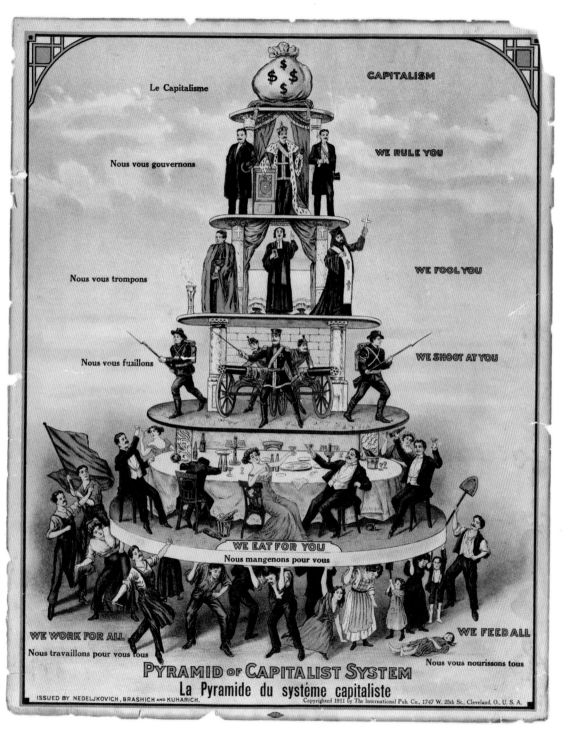

PYRAMID OF CAPITALIST SYSTEM

La Pyramide du systéme capitaliste

ISSUED BY NEDELJKOVICH, BRASHICH AND KUHARICH.

Copyrighted 1911 by The International Pub. Co., 1747 W. 25th St., Cleveland, O., U. S. A.

▽ *From the Depths* by William Balfour (Canadian-
American, 1877–1918), photomechanical print:
photogravure, published in *The Silent War* by John
Ames Mitchell, Life Publishing Company, New York,
1906

▷ Human Statue of Liberty. 18,000 Officers and Men
at Camp Dodge, Des Moines, IA Col. Wm. Newman
commanding. Col. Rush S. Wells directing, photograph
by Arthur Mole (American, 1889–1983) and John
Thomas (American, d. 1947), gelatin silver print,
Chicago, United States, *c.* 1918

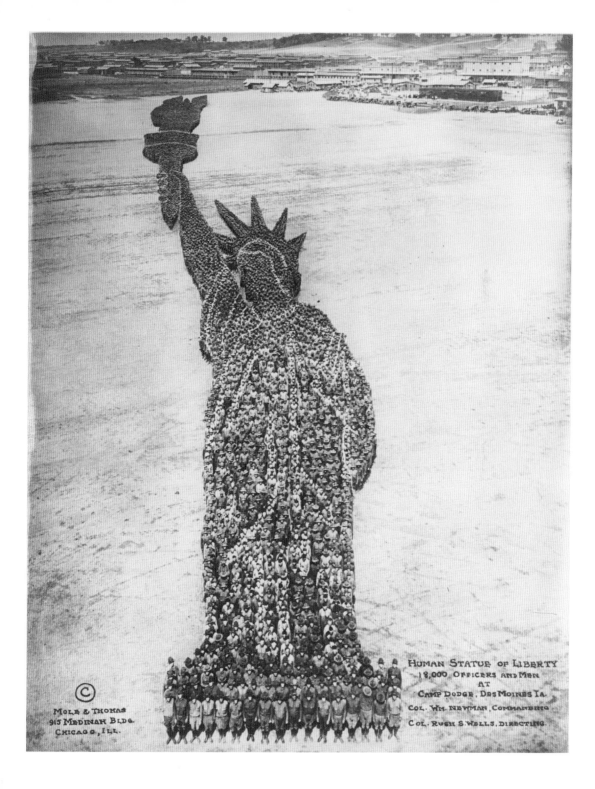

HUMAN STATUE OF LIBERTY
18,000 OFFICERS AND MEN
AT
CAMP DODGE, DES MOINES IA.
COL. WM. NEWMAN, COMMANDING
COL. RUSH S. WELLS, DIRECTING.

CITY AND RURAL POPULATION.
1890.

OCCUPATIONS OF NEGROES AND WHITES IN GEORGIA.

NEGROES.

AGRICULTURE, FISHERIES AND MINING.

MANUFACTURING AND MECHANICAL INDUSTRIES.

DOMESTIC AND PERSONAL SERVICE.

PROFESSIONS.

TRADE AND TRANSPORTATION.

WHITES.

NEGRO TEACHERS IN GEORGIA PUBLIC SCHOOLS.

2512
1886

2500
1889

3208
1893

3316
1897

ASSESSED VALUATION OF ALL TAXABLE PROPERTY OWNED BY GEORGIA NEGROES.

$5,393,885

1875

1885

1890

◁ (a) City and Rural Population, (b) Occupations of Negroes and Whites in Georgia, (c) Negro Teachers in Georgia Public Schools, and (d) Assessed Valuation of All Taxable Property owned by Georgia Negroes, from *The Georgia Negro* by W. E. B. Du Bois (American 1868–1963), ink and watercolor, prepared for the Negro Exhibit of the American Section at the Paris Exposition Universelle, 1900. Du Bois presented a total of 58 charts at the Paris Exposition, alongside an extensive collection of patents, photographs, and books by African Americans, to show the economic and social progress of African Americans since emancipation. While disregarded by the American media at large, this work received wide exposure and is considered a groundbreaking moment in the struggle for equal rights.

▽ Beggar next to the Carriage of the English King George V (1865–1936), photographer unknown, Epsom Downs, Derby Day, 1920

140 ▽ *Shoes* by Vincent van Gogh (Dutch, 1853–90), oil on canvas, 1888

▷ *The Arrival of the Jarrow Marchers in London, Viewed from an Interior* by Thomas Cantrell Dugdale (British, 1880–1952), oil on canvas, 1936. On October 5th, 1936, 200 unemployed men and their local member of parliament, Ellen Wilkinson, left Jarrow in North East England to walk to London, a distance of almost 250 miles. Changing economic circumstances following the First World War and the Great Depression had led to the closure of Jarrow's main employer, Palmers shipyard. Out of a total population of 35,000, 23,000 citizens of Jarrow were on the "dole" or dependent upon other welfare or relief payments. Only 100 out of 8,000 skilled manual workers in the town were still in full-time employment at the time of the march. The marchers carried a petition, signed by nearly 12,000 Jarrow citizens, which they hoped to present to Parliament. The petitioners, it said, "humbly pray that His Majesty's Government and this honourable House will realise the urgent need that work should be provided for the town without delay."

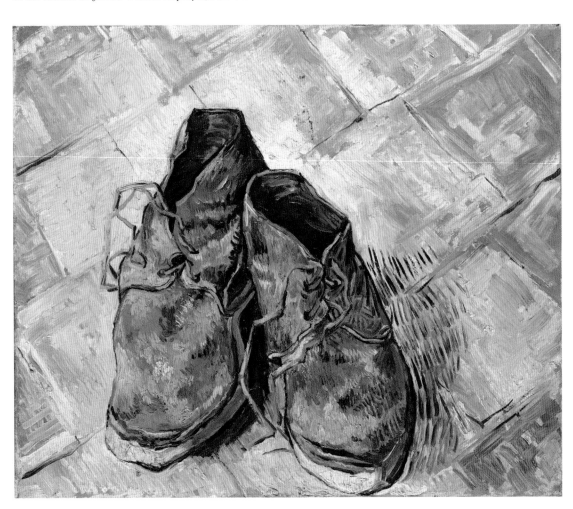

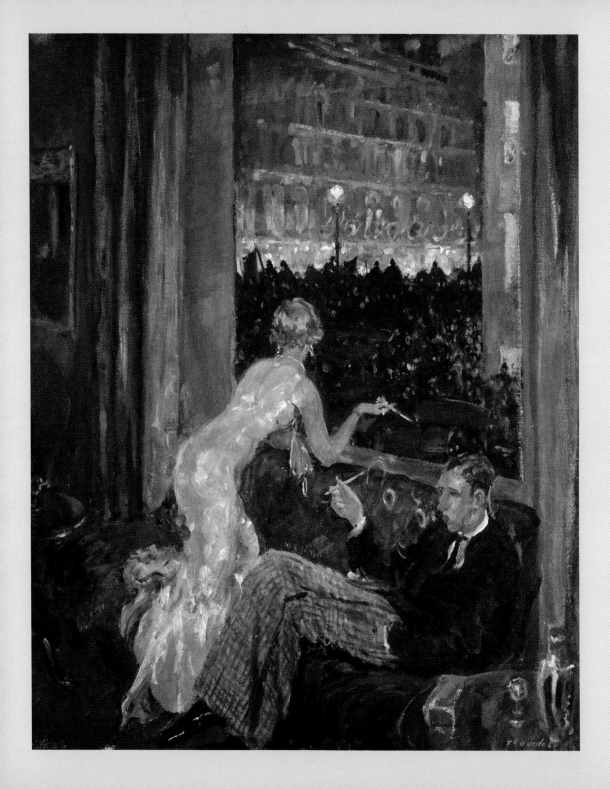

Poverty is not caused by men and women getting married; it's not caused by machinery; it's not caused by "over-production"; it's not caused by drink or laziness; and it's not caused by "over-population." It's caused by Private Monopoly. That is the present system. They have monopolized everything that it is possible to monopolize; they have got the whole earth, the minerals in the earth and the streams that water the earth. The only reason they have not monopolized the daylight and the air is that it is not possible to do it. If it were possible to construct huge gasometers and to draw together and compress within them the whole of the atmosphere, it would have been done long ago, and we should have been compelled to work for them in order to get money to buy air to breathe. And if that seemingly impossible thing were accomplished tomorrow, you would see thousands of people dying for want of air—or of the money to buy it—even as now thousands are dying for want of the other necessities of life.

—Robert Tressell, *The Ragged-Trousered Philanthropists*, 1914

◁◁ *Arbeiterstadt (Working-class City)* by Hans
Baluschek (German, 1870–1935), oil on canvas, 1920

▽ Negroes in the Lineup for Food at Mealtime in the
Camp for Flood Refugees, Forrest City, Arkansas, by
Walker Evans (American, 1903–75), gelatin silver print,
1937

▷ A Southern Chain Gang, artist unknown, published
by Detroit Publishing Company, United States,
c. 1901–06

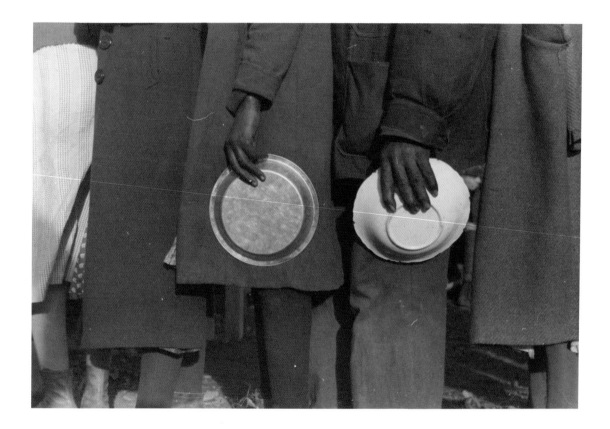

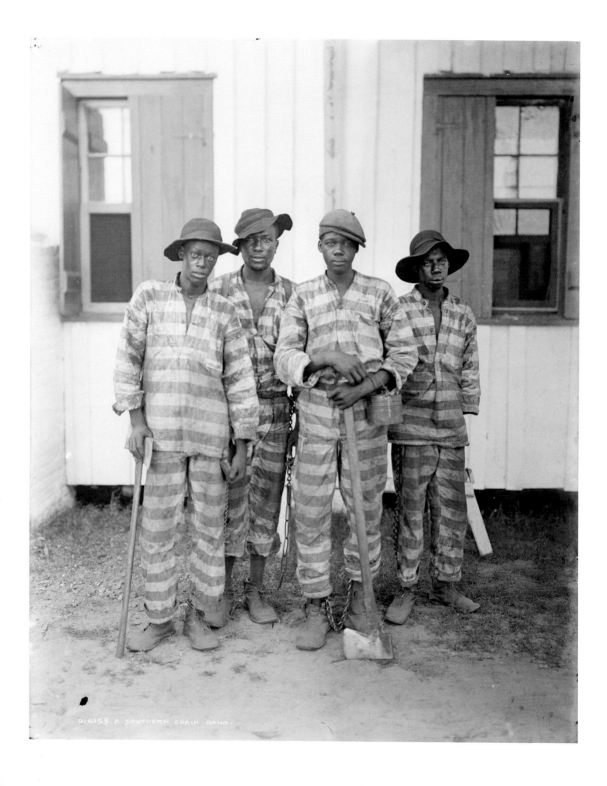

D16155. A SOUTHERN CHAIN GANG.

▽ *Refugees* by Josef Herman (Polish-British,
1911–2000), gouache on paper, *c.* 1941

I will always be on the side
of those who have nothing
and are not even allowed to enjoy
the nothing they have in peace.

—Federico García Lorca (1898–1936)

◁ From the wordless novel *The City* by Frans Masereel (Flemish, 1889–1972), woodcut print, 1925

▽ *Metropolis* by George Grosz (German, 1893–1959), oil on canvas, 1916–17

▽ (a) *From Slavery to Reconstruction* and (b) *An Idyll of the Deep South*, from *Aspects of Negro Life* by Aaron Douglas (American, 1899–1979), oil on canvas, 1934

▷ *Corridor in the Asylum* by Vincent van Gogh (Dutch, 1853–1890), oil color and essence over black chalk on pink laid (Ingres) paper, 1889

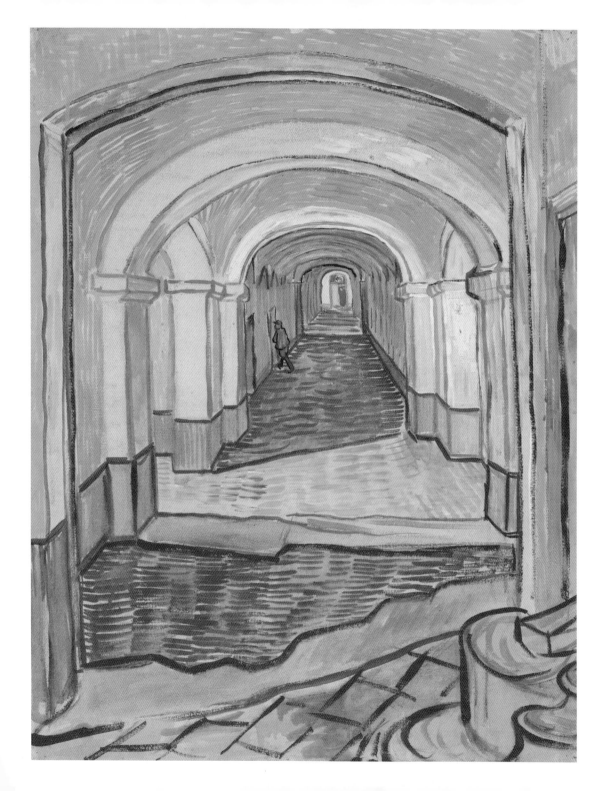

▽ *Der Strauß* (*The Bouquet*) by Hannah Höch
(German, 1889–1978), collage and photomontage,
1929 and 1965

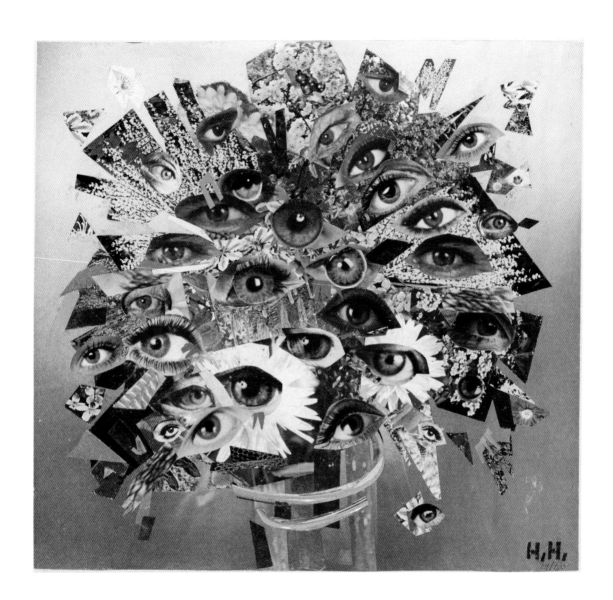

▽ *Untitled (Los Mellizos Cubanos)* by Felipe Jesus Consalvos (Cuban-American, 1891 – *c.* 1960), printed material, glue on paper, *c.* 1920/50. A former cigar roller, Consalvos is credited with elevating the tradition of cigar band collage, drawing from satirical, absurdist, and mystical elements and foreshadowing much later trends. His large body of work was rediscovered posthumously at a West Philadelphia garage sale, untitled and undated.

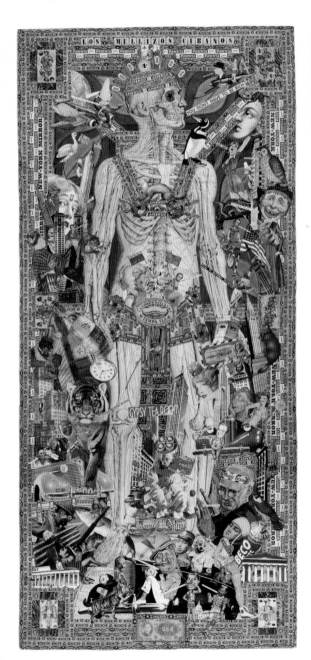

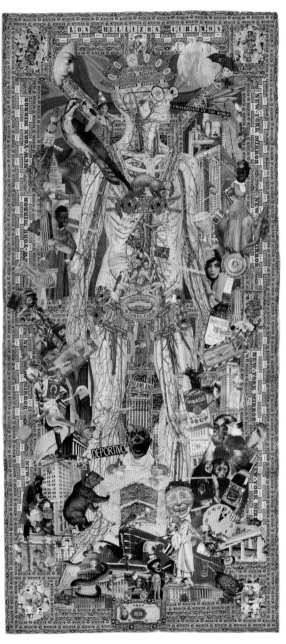

154 ▽ *Bird in Hand* by Ellen Gallagher (American, b. 1965), oil paint, ink, paper, polymer, salt, and gold leaf on canvas, 2006

▷ Two German Women Sitting on a Park Bench Surrounded by Destroyed Buildings by Lee Miller (American, 1907–77), Cologne, Germany 1945

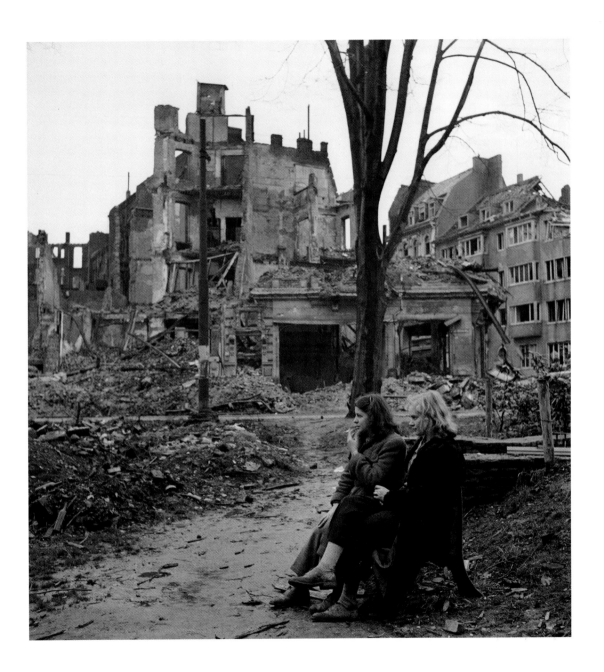

◁ *Mask Masked* by Gillian Wearing (British, b. 1963), fabric mask, wax sculpture, steel rod, and wooden base, 2020

▽ *Fears* by Louise Bourgeois (French American, 1911–2010), wood and metal, 1992

▷▷ *Fervor* by Shirin Neshat (American, b. 1957 in Iran), gelatin silver print, 2000

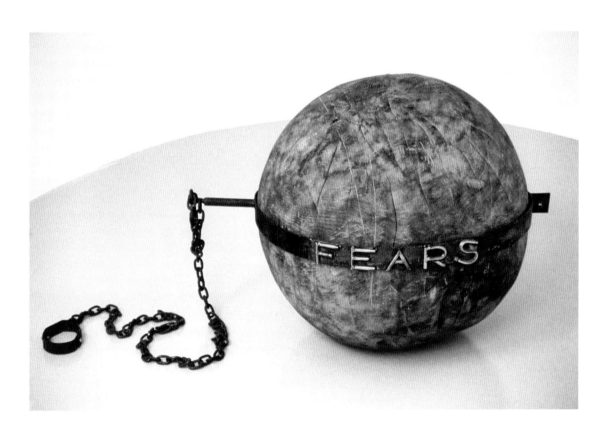

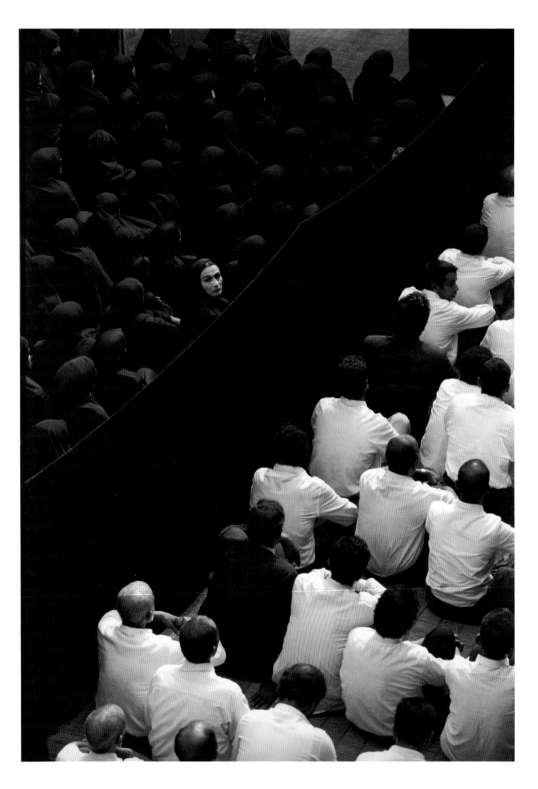

Death lurked everywhere, but this was a different sort of death. Donning new masks, wearing a strange guise. Man had been caught off-guard, he was not ready. Ill-prepared as a species, our entire natural apparatus, attuned to seeing, hearing, and touching, had malfunctioned.

—Svetlana Alexievich, *Chernobyl Prayer: Voices From Chernobyl*, 1997

Lies

I am so tired of waiting,
Aren't you,
For the world to become good
And beautiful and kind?
Let us take a knife
And cut the world in two—
And see what worms are eating
At the rind.

—Langston Hughes, "Tired," *New Masses*, vol.6, no.9, 1931

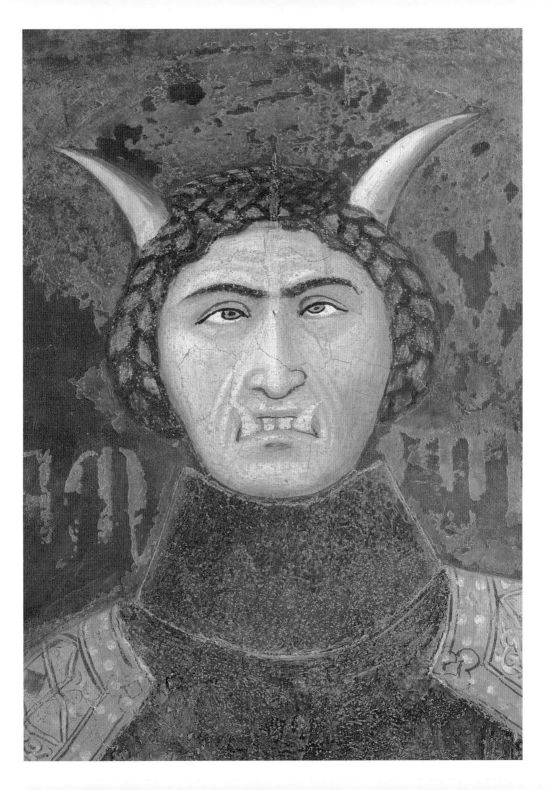

◁◁ The Tyrant, detail from *Allegory of Good and Bad Government* by Ambrogio Lorenzetti (Italian, 1285 – *c.* 1348), fresco in Palazzo Pubblico, Siena, Italy, 1337–39

▽ *Crouching Midget* by Aubrey Vincent Beardsley (English, 1872–98), pen and black ink on ivory wove paper, *c.* 1892–98

▽ A skeleton holding a bone and leaping over a pile of skulls while people flee, from a broadside entitled *Las bravisimas calaveras Guatemaltecas* by José

Guadalupe Posada (Mexican, 1851–1913), wood engraving, *c.* 1880–1910

165

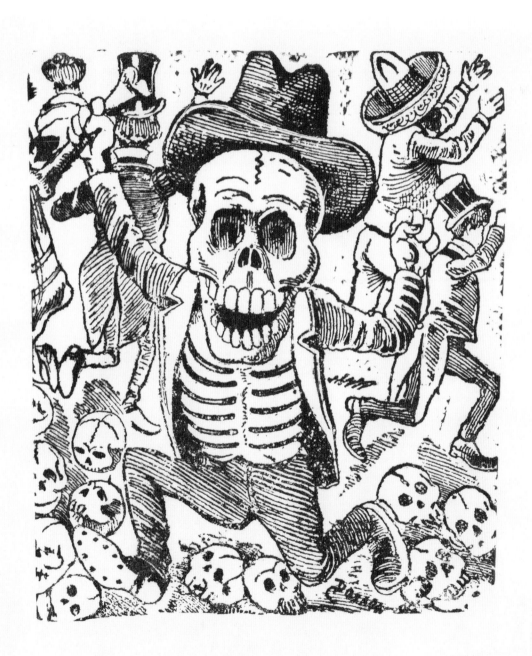

166 ▽ *Kul'tura kapitalisticheskaia. Khristianstvo – vysshee dostizhenie chelovecheskoi kul'tury, (Iz rechi episkopa Kenterberiiskogo), (Capitalist culture, Christianity is the highest achievement of human culture [from a speech by the Archbishop of Canterbury])*, by K. Urbetis, cover of *Bezbodzhnik u stanka*, 1930

▷ (a) *The Gothic Arch*, plate 14, and (b) *The Well*, plate 13, from *Carceri d'Invenzione* (*Imaginary Prisons*), Giovanni Battista Piranesi (Italian, 1720–78), etchings, *c.* 1750

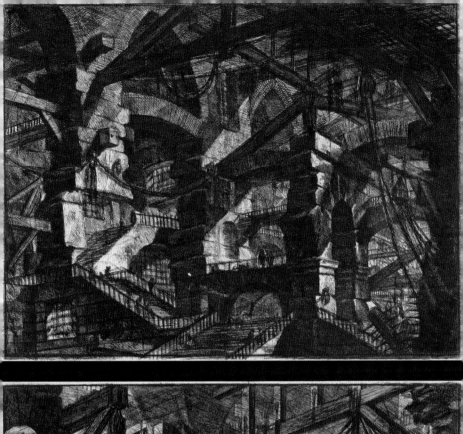

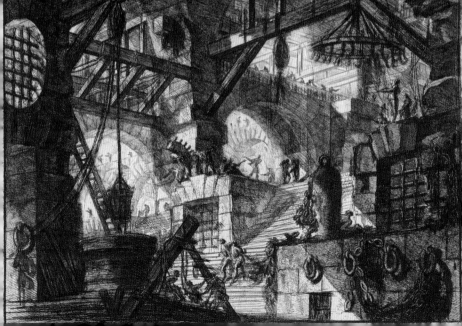

G. Doré

BERTRAND Sc.

◁ *The Council Held by the Rats*, after Gustave Doré (French, 1832–83), engraved by Antoine-Valérie Bertrand (French, b. 1823), wood engraving, *c.* 1868

▽ *Agnus Dei* (*Lamb of God*) by Francisco de Zurbarán (Spanish, 1598–1664) oil on canvas, *c.* 1635–40 169

▽ A Man on Horseback Enters a Church to Discover an Orgiastic Sabbath, artist unknown, watercolor with gum arabic, no further details known

▷ *Death of International Imperialism* by Dmitry Moor (Russian, 1833–1946), Soviet poster, 1919

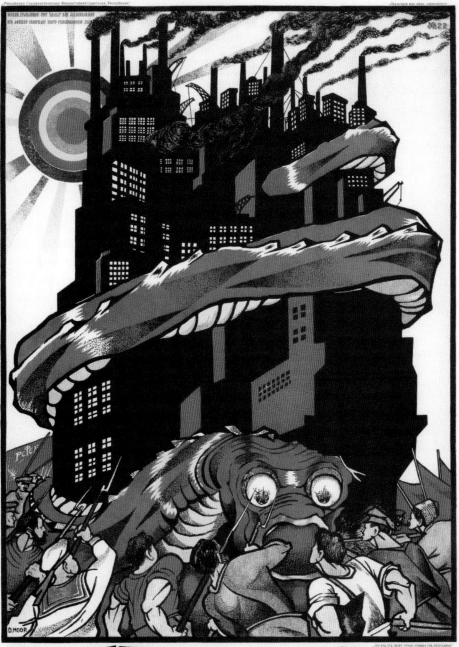

172 ▽ *The Man Wots Got the Whip Hand of 'Em All* by
William Heath (British, 1794–1840), satirizing the free
press, possibly published in *Paul Pry*, a newspaper
dedicated to exposing political corruption and religious
fraud, hand-colored engraving, 1820

▷ *Satan semant l'ivraie (Satan Sowing the Tare)* by
Félicien Victor Joseph Rops (Belgian, 1833–98), soft
ground etching, 1906

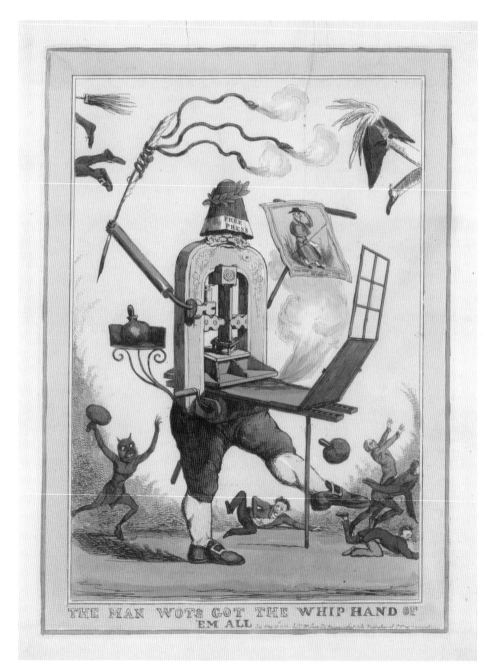

THE MAN WOTS GOT THE WHIP HAND OF
EM ALL

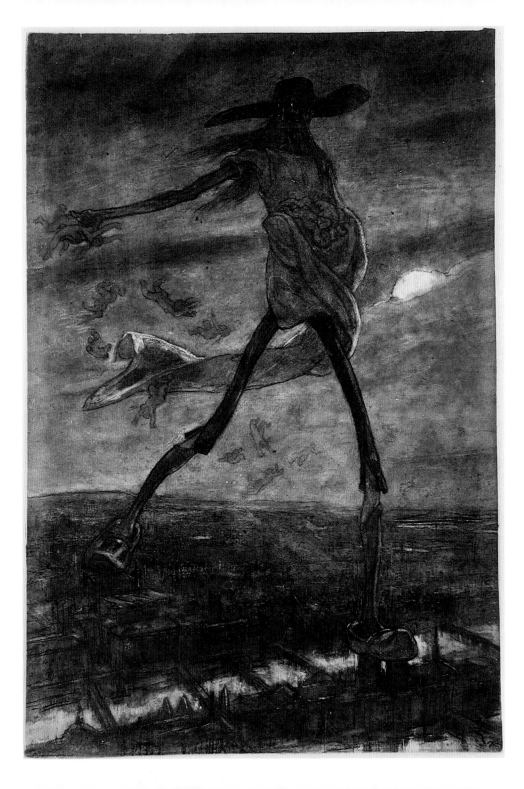

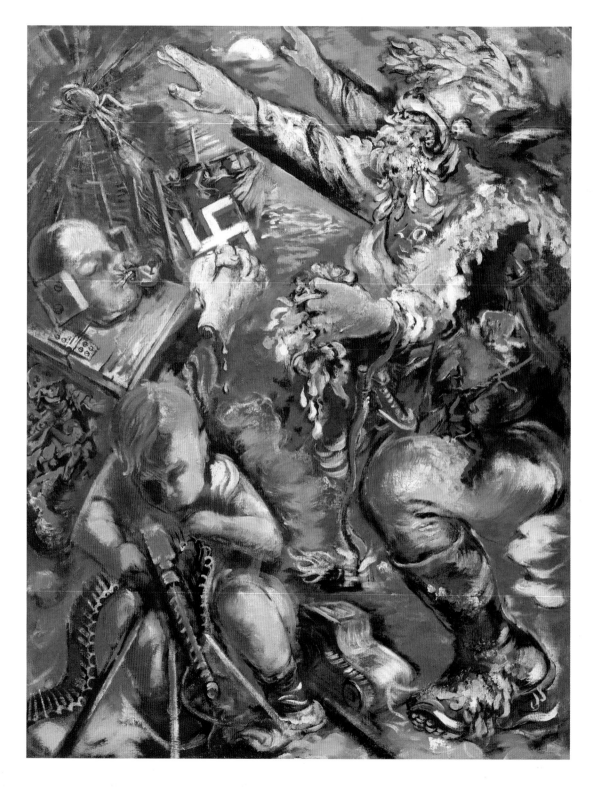

World War III is a guerrilla information war with no division between military and civilian participation.

—Marshall McLuhan, *Culture Is Our Business*, 1970

The real problem of humanity is the following: we have paleolithic emotions; medieval institutions; and god-like technology.

—E. O. Wilson, 2009

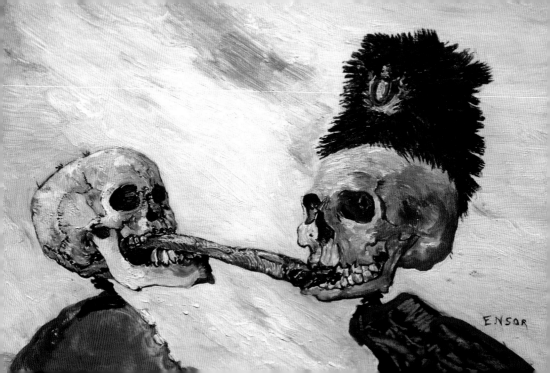
ENSOR

◁◁ *God of War* by George Grosz (German, 1893–1959), oil on canvas, 1940

◁ *Skeletons Fighting over a Smoked Herring* by James Ensor (Belgian, 1860–1949), oil on wood, 1891

▽ *Gatos riñendo* (*Cats Fighting*) by Francisco de Goya (Spanish, 1746–1828), oil on canvas, 1786

▽ *City Limits* by Philip Guston (Canadian American, 1913–80), oil on canvas, 1969

The ultimate, hidden truth of the world
is that it is something that we make,
and could just as easily make differently.

—David Graeber, *The Utopia of Rules: On Technology, Stupidity,
and the Secret Joys of Bureaucracy*, 2015

◁ *Der Schützengraben* (*The Trench*) by Otto Dix (German, 1891–1969), gouache and opaque white on paper, *c.* 1917

▽ *The Mothers* by Käthe Kollwitz (German, 1867–1945), woodcut on Japanese paper, 1921–22

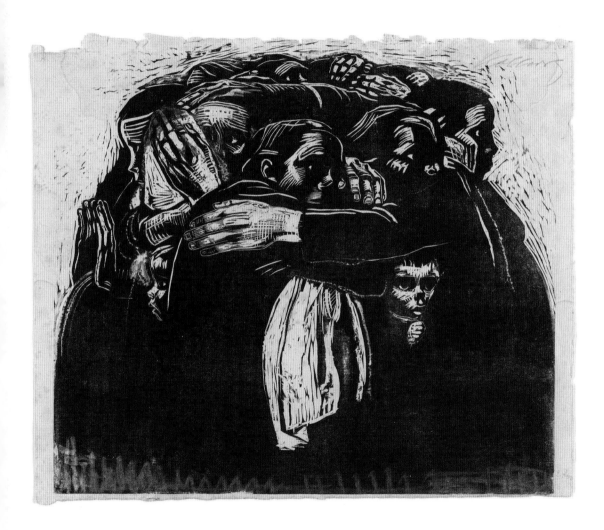

▽ *Valley of the Shadow of Death* by Roger Fenton
(English, 1819–69), salted paper print, Crimea, Ukraine,
1855. A famous image from the Crimean War capturing
a valley littered with cannonballs. The emergence in
1981 of a second photograph of the valley with fewer
cannonballs sparked discussion around which came

first, opening the possibility that this is one of the
earliest staged press photographs.

▷ The Wilderness Battlefield, artist unknown, albumen
silver print from glass negative, American, 1864

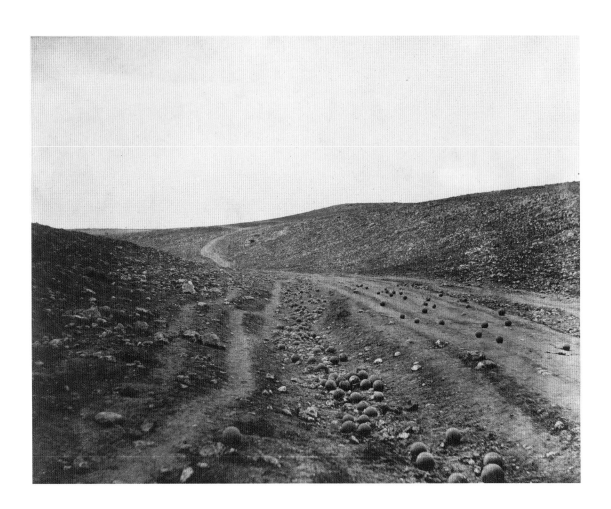

▽ *Abandoned Dust Bowl Home* by Dorothea Lange (American, 1895–1965), gelatin silver print, *c.* 1935–40

▷ *Heavy Black Clouds of Dust Rising Over the Texas Panhandle, Texas* by Arthur Rothstein (American, 1915–1985), nitrate negative, 1936

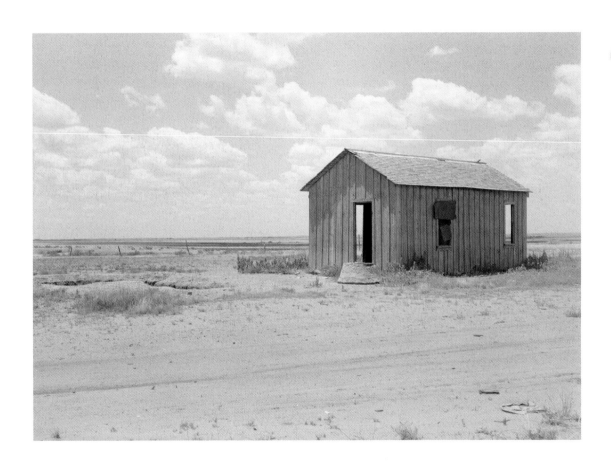

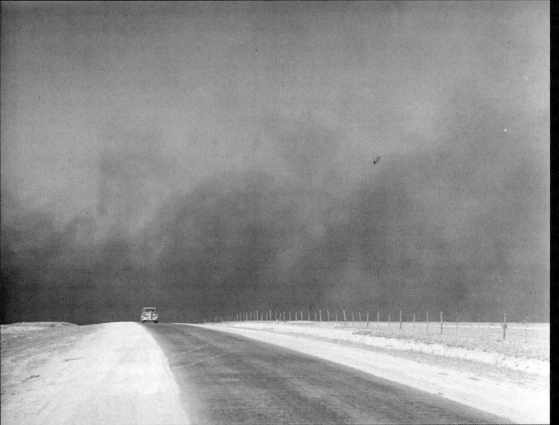

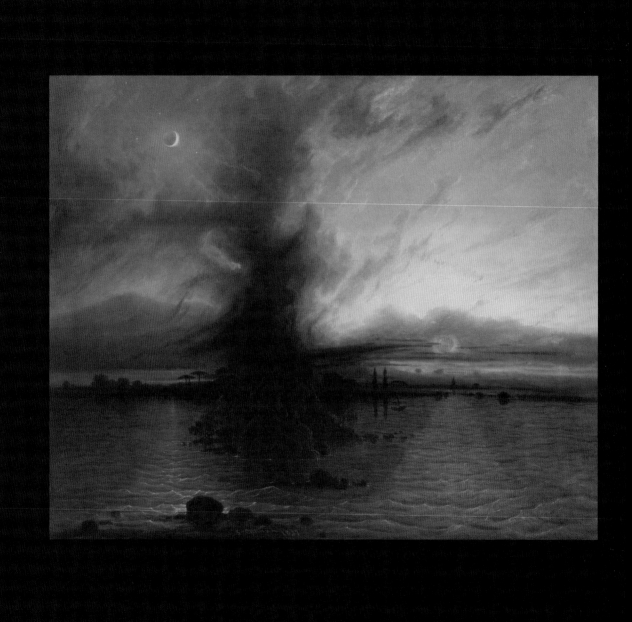

◁ *The Rock of Salvation* by Samuel Colman (British, 1780–1845), oil on canvas, 1837

▽ *Iceberg Fantasy* by Frederic Edwin Church (American, 1826–1900), brush and oil on buff cardboard, 1859

188 ▽ *Moonlight, Wolf* by Frederic Remington (American,
1861–1909), oil on canvas, *c.* 1909

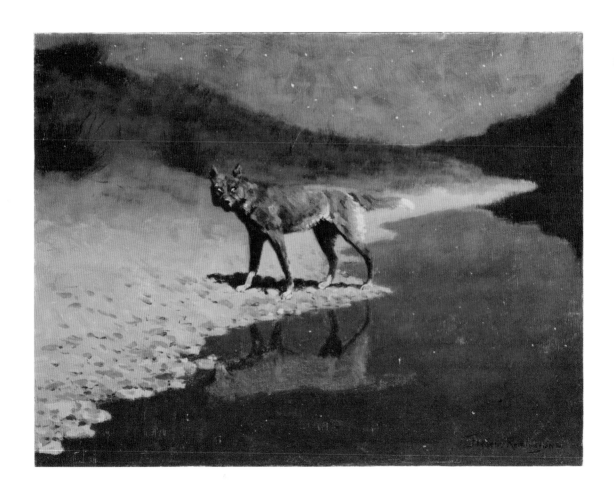

When the people are being beaten with a stick, they are not much happier if it is called "the People's Stick."

—Mikhail Bakunin, *Statism and Anarchy*, 1873

If we behave like those on the other side, then we are the other side. Instead of changing the world, all we'll achieve is a reflection of the one we want to destroy.

—Jean Genet, *The Balcony*, 1957

Rise

I am going to light a fire in Paradise and pour
water on Hell, so that both veils (hindrances to
the true vision of God) completely disappear.

—Rābi'a al-'Adawiyya al-Qaysiyya (714–801 CE)

The sleepwalkers are
coming awake, and for the
first time this awakening
has a collective reality; it is
no longer such a lonely thing
to open one's eyes.

—Adrienne Rich, "When We Dead Awaken: Writing as Re-Vision,"
College English, vol. 34, no. 1, 1972

▽ *Koi no taki nobori* (*Carp Swimming up a Waterfall*) by Yashima Gakutei (Japanese, *c.* 1786–1868), color woodblock print; surimono, silver, gold, and brass, *c.* 1827–28

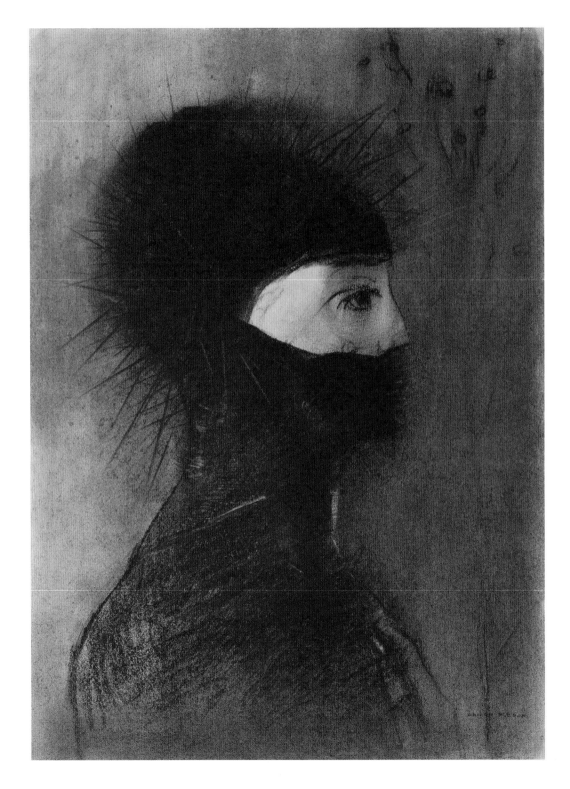

◁ *Armour* by Odilon Redon (French, 1840–1916), charcoal and conté crayon, 1891

▽ *Barricades de la Commune, avril 71. Coin de la place Hotel de Ville & de la rue de Rivioli* by Pierre-Ambrose Richebourg (French, 1810–1893), albumen silver print, 1871

195

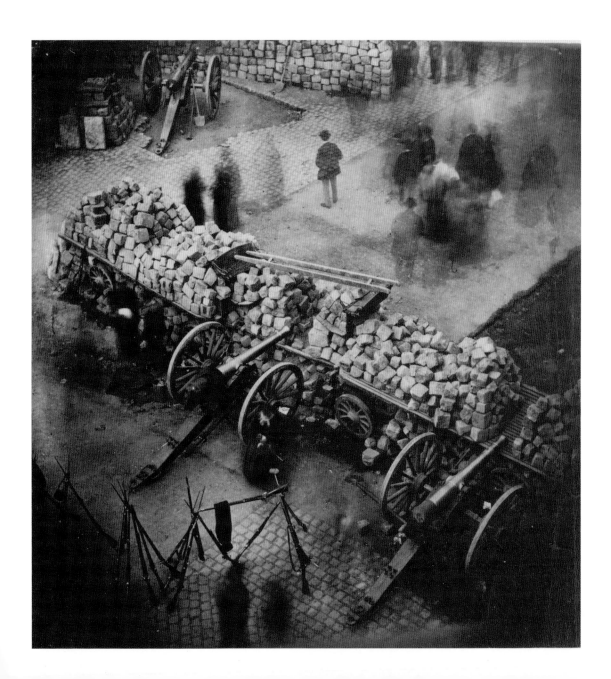

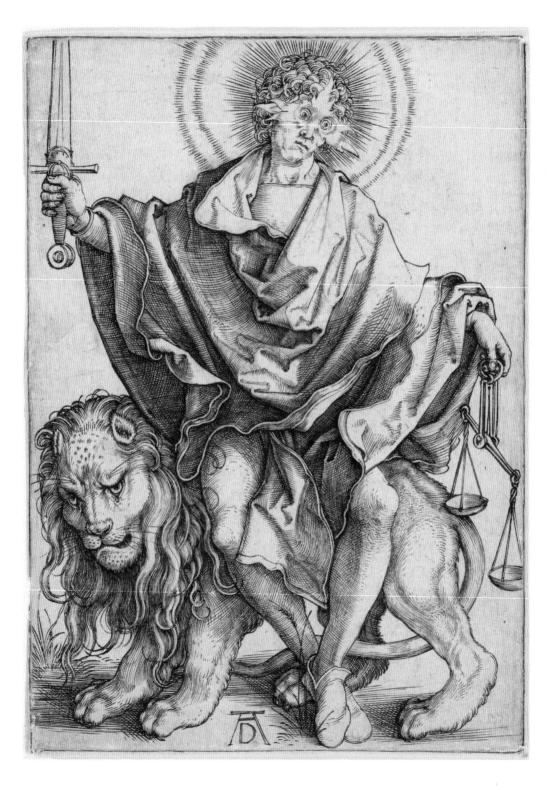

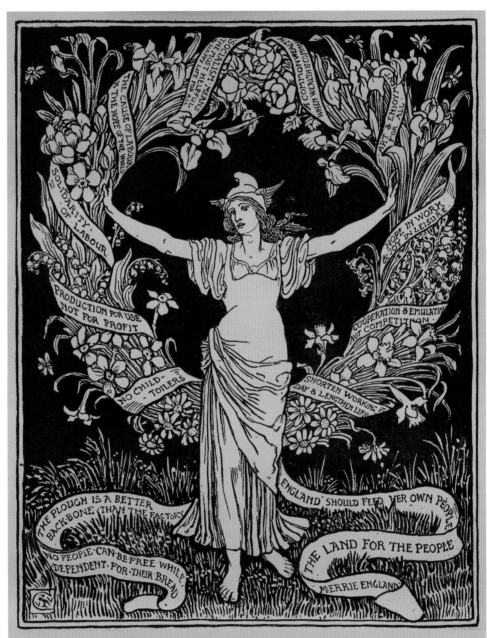

· A · GARLAND · FOR · MAY · DAY · 1895 ·
· DEDICATED · TO · THE · WORKERS · BY · WALTER · CRANE ·

▽ Abolitionist Jug, artist unknown, pearlware (glazed earthenware) with transfer-printed and luster decoration, British, probably Staffordshire or Sunderland, *c.* 1820

▷ *Haiti, a Drama of the Black Napoleon* by Vera Bock (Russian-American, 1905–73), advertising the play by William Du Bois for the Lafayette Theatre, silkscreen, color, 1938

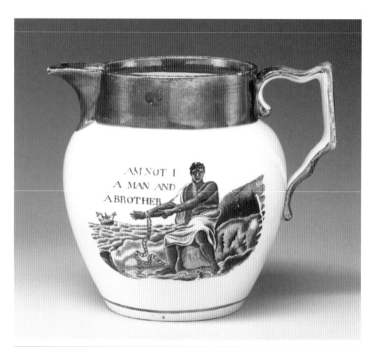

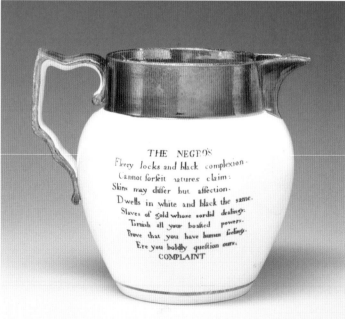

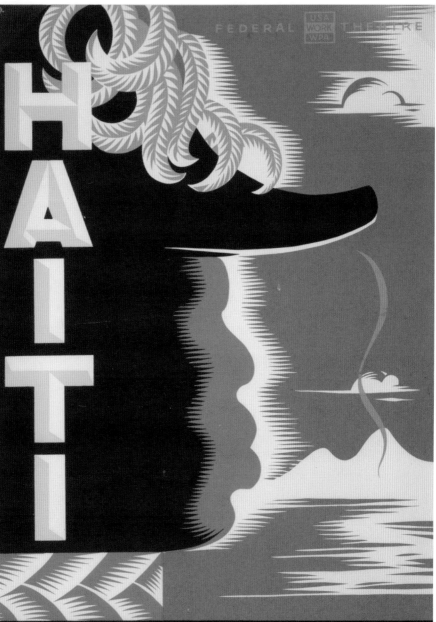

▽ The Death of Munrow, artist unknown, lead-glazed earthenware with enamel decoration, *c*. 1820–30. This earthenware tableau depicts a particular event in which a tiger killed a British soldier in India in 1791. The figure draws inspiration from *Tipu's Tiger*, a large mechanized wooden sculpture of a similar attack owned by Tipu Sultan, ruler of the Indian kingdom of Mysore, which was stolen from Tipu's palace by British troops employed by the East India Company in 1799, and which is now in the collection of the Victoria and Albert Museum, London.

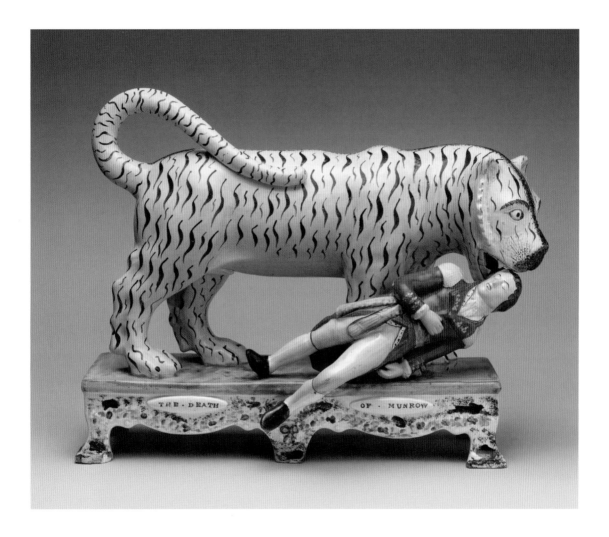

▽ *Judith and her Maidservant (with the Head of Holofernes)* by Artemisia Gentileschi (Italian, 1593– 1653), oil on canvas, *c.* 1615 ▷ *A Capri Witch* by Marianne Stokes-Preindlsberger (Austrian, 1855–1927), oil on panel, 1884–85

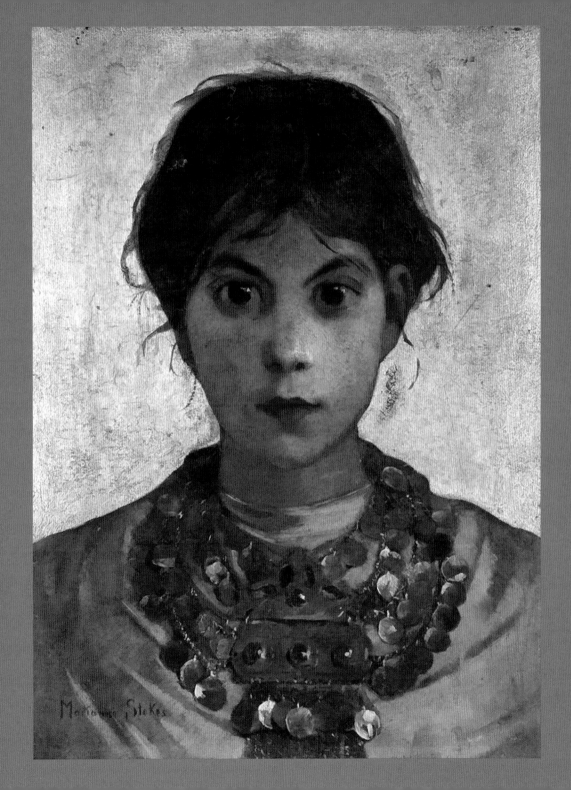

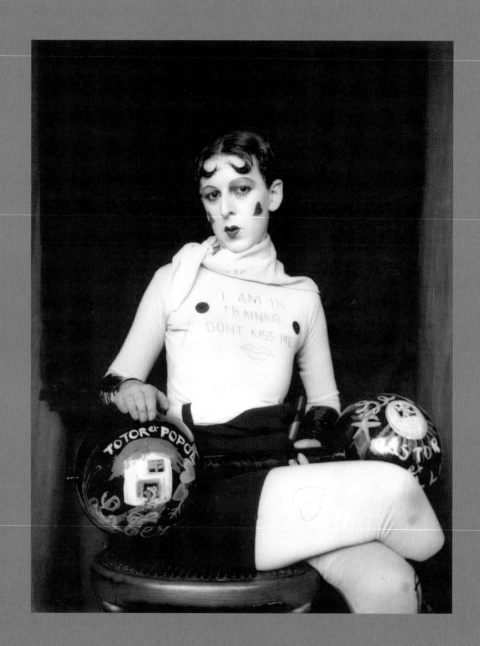

◁ *I am in training don't kiss me* by Claude Cahun, pseudonym of Lucy Renée Mathilde Schwob (French, 1894–1954), monochrome print, 1927

▽ (a) Two men in elaborate drag, photoprint, 1920s, (b) Man in drag, photoprint with watercolor, 1890s, (c) Man in drag, photoprint with watercolor, 1890s, (d) Two men in drag posing in the act of dressing, photoprint with watercolor, 1890s

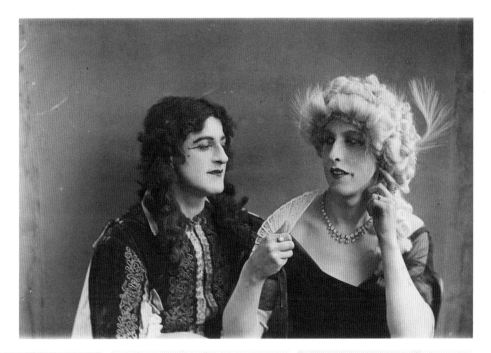

▽ Woman's Rights Quilt by Emma Civey Stahl (American, b. *c.* 1860), cotton, *c.* 1875. The quilt features two sets of vignettes. The first depicts scenes from the American Civil War; the second chronicles, and perhaps satirizes, an activist for women's rights, who is shown leaving a husband and child to travel and lecture to a startled and intimidated audience.

▷ Woman Beating a Man With a Broom by unknown Kalighat artist, Calcutta, 9th century

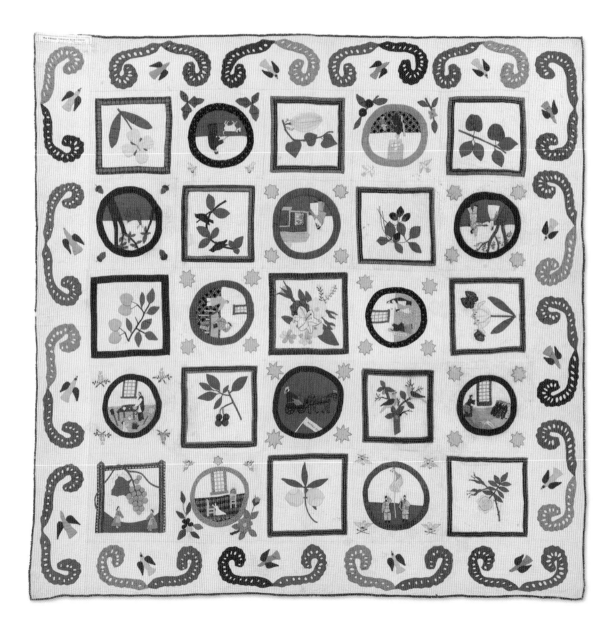

競勢酔虎傳

大塩平八郎

兵法の大綱中。奈す
庵こののらざるとのハ大義
名え分えありとのや。大塩
軍畧み長たると雖ハ

惜む一ー此名
分と失ち。ゆえに。
敷百騎を辛ひて山崎口より直地み
關下に迫らんと書に。諸藩士慣發防戦
志く大業空しく討死せり。此役
兵火み罹り移る。市民の老少荷と
脊負ひ東西み奔走し。甚惘然み
景況ハ夢物語とつ書たえも乢

三筋御の隠士
粋々室鈍々記

大藪芳年

◁ A Hero Holding a Banner Aloft before a Western Cannon by Yoshitoshi (Japanese, 1839–92), woodcut, 1875

▽ *Long live the fifth anniversary of the Great Proletarian Revolution!* by the Fourth Congress of the Communist International, color lithograph poster, Soviet Union, 1922

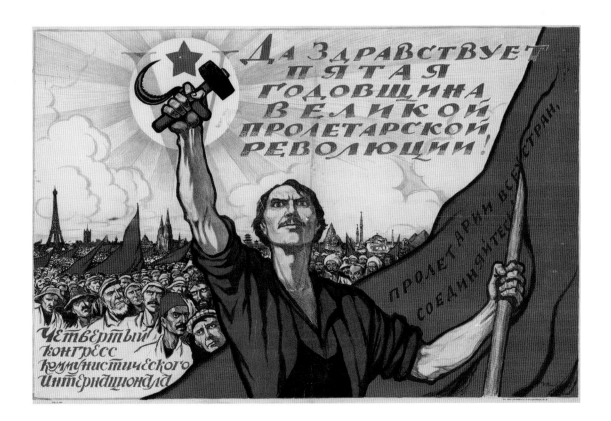

▽ Suffrage poster from an issue of the periodical *The Suffragette*, with a figure of a woman, "Justice," clad in armor, bearing a banner labeled "W.S.P.U." by Hilda M. Dallas (British, 1878–1958), lithograph, *c.* 1912–15

▷ *Woman Suffrage . . . Give her the fruit of her hands, and let her own works praise her in the gates* by Evelyn Rumsey Cary (American, 1855–1924), lithograph, no date

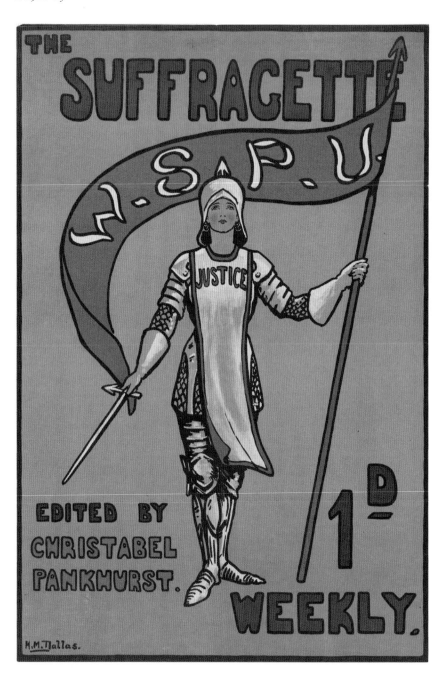

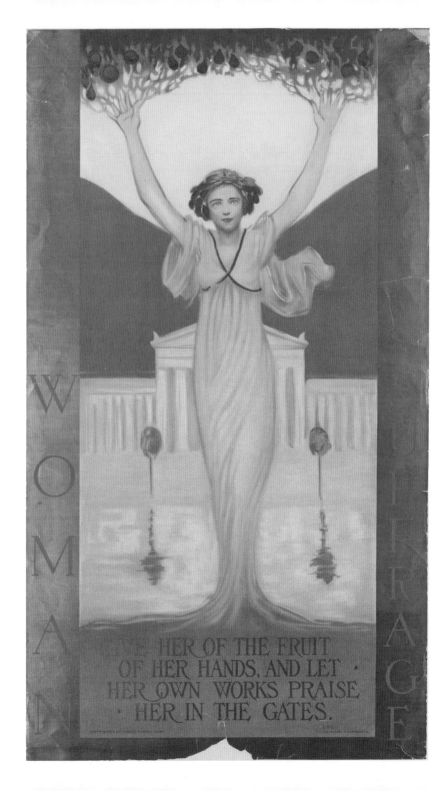

WOMAN SUFFRAGE

GIVE HER OF THE FRUIT
OF HER HANDS, AND LET ·
HER OWN WORKS PRAISE
· HER IN THE GATES.

▽ *The Emperor's New Clothes* by Harry Reminick (American, b. 1913), for the Works Progress Administration in Ohio presenting The Federal Theatre for Youth, silkscreen, color, 1937

▷ Suffrage in the British press, posters, printed: (a) Wild Women at the Horse Show, 1910–13; (b) Rowdy Scenes Before the King & Queen, c. 1914; (c) Armed Women Besiege the King, May 21st, 1914; (d) Suffragettes Batoned By Police, c. 1912

WILD WOMEN AT THE HORSE SHOW

Evening News 6·30 CLOSE

ROWDY SCENES BEFORE THE KING & QUEEN

WESTMINSTER FINAL EDITION.

ARMED WOMEN BESIEGE THE KING

The Globe SPECIAL EDITION

21.5.14

SUFFRAGETTES BATONED BY POLICE

Evening News 6·30

The place in which I'll fit
will not exist until I make it.

—James Baldwin, from a letter to Sol Stein, 1957

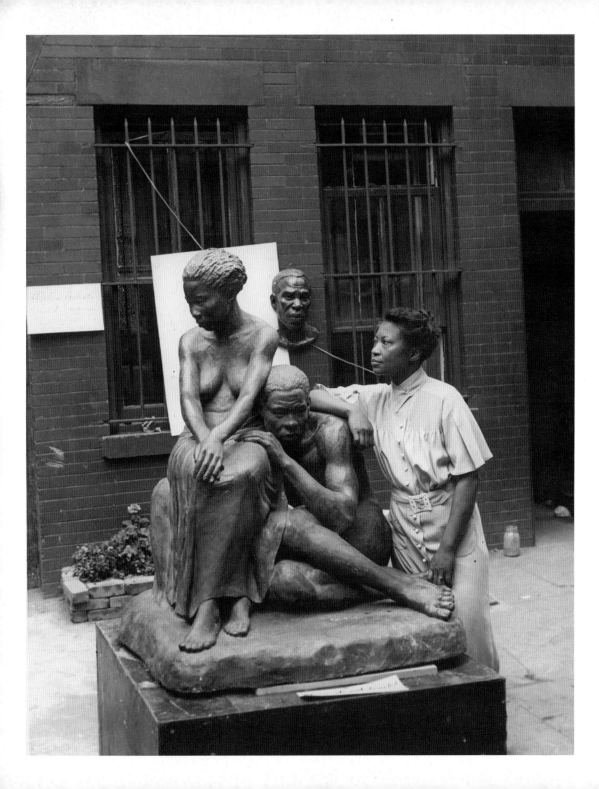

216 ◁◁ Augusta Savage (American, 1892–1962) with her sculpture *Realization*, photograph by Andrew Herman, gelatin silver print, 1936. Augusta Savage was a Harlem-based sculptor, educator, and lifelong advocate of African American artistry. She was the first African American woman to open her own art gallery. Sadly, just 12 of her works have survived.

▽ Advance Swiftly! Build the motherland Protect the motherland, artist unknown, Chinese propaganda poster, 1970s

▷ *The More Women at Work the Sooner We Win!*, photograph by Alfred T. Palmer for United States Office of War Information, Bureau of Public Inquiries, photomechanical print (poster): halftone, color, 1943

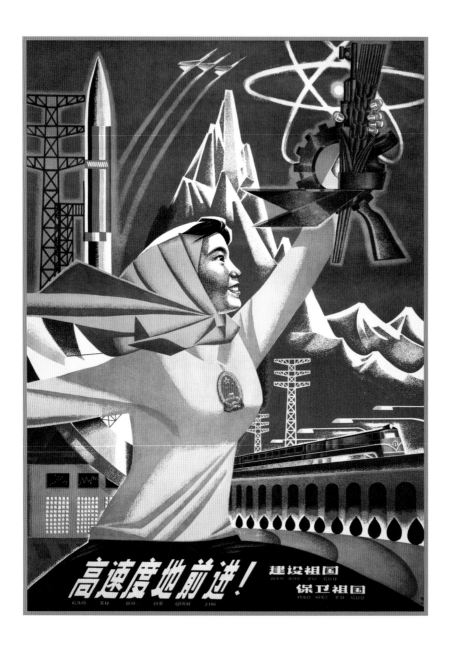

The more WOMEN at work the sooner we WIN!

WOMEN ARE NEEDED ALSO AS:

FARM WORKERS	WAITRESSES	TIMEKEEPERS	LAUNDRESSES
TYPISTS	BUS DRIVERS	ELEVATOR OPERATORS	TEACHERS
SALESPEOPLE	TAXI DRIVERS	MESSENGERS	CONDUCTORS

—and in hundreds of other war jobs!

SEE YOUR LOCAL U.S. EMPLOYMENT SERVICE

OWI Poster No. 52. Additional copies may be obtained upon request from the Division of Public Inquiries, Office of War Information, Washington, D. C. U. S. GOVERNMENT PRINTING OFFICE 1943 O-517154

▽ *Beat the Whites with the Red Wedge* by El Lissitzky, Soviet propaganda poster, lithograph print, *c.* 1919

▷ Partido Obrero de Unificación Marxista (POUM) (The Workers' Party of Marxist Unification) propaganda poster showing the fight against fascism during the Spanish Civil War, artist and date unknown

▷▷ *Woman with Flag* by Tina Modotti (Italian American, 1896–1942), Mexico City, 1928, used on cover of A-J-Z, 1931

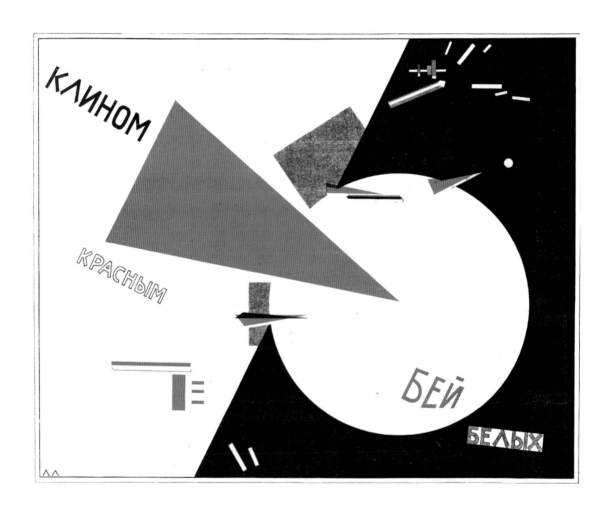

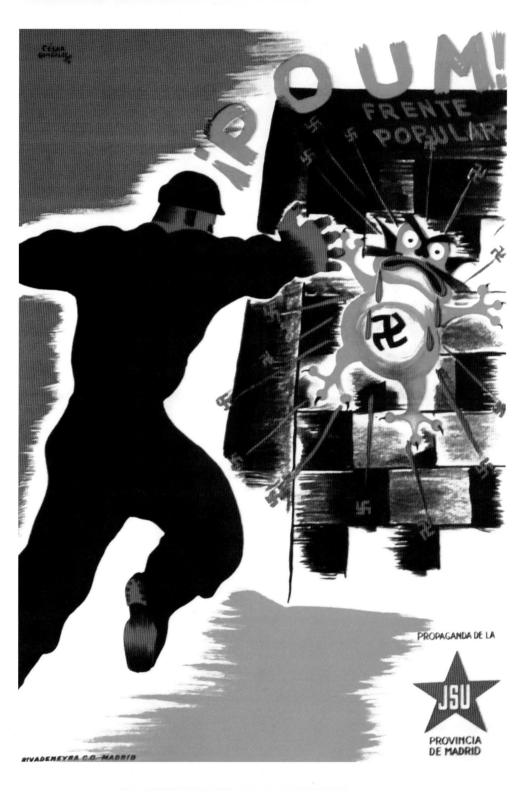

JAHRGANG X
Nr. 17 1931
Preis:
20 Pfg., Kc. 1.60,
15 Kop., 30 Gr.
V. b. b

A·I·Z

1.MAI

**KAMPFTAG
DER ROTEN
WELTARMEE**

Mexikanische Bergarbeiterfrau

Foto: Tina Modotti

All women speak two languages:
the language of men and the
language of silent suffering.
Some women speak a third,
the language of queens.

—Mohja Kahf, *E-mails from Scheherazad*, 2003

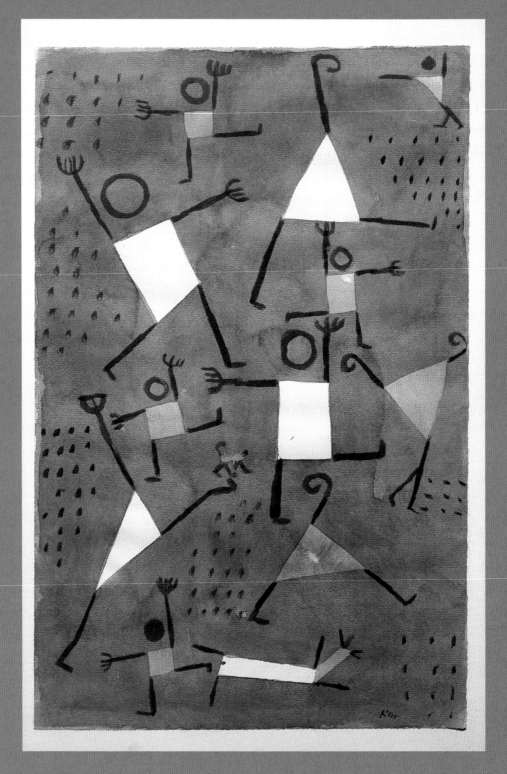

◁ *Tänze vor Angst* (*Dancing for Fear*) by Paul Klee (Swiss-born German, 1879–1940), watercolor on paper on cardboard, 1938

▽ *The 1920's . . . The Migrants Cast Their Ballots* from Kent Bicentennial Portfolio: Spirit of Independence by Jacob Lawrence (American, 1917–2000), serigraph in seven colors plus white on domestic etching paper, 1974

223

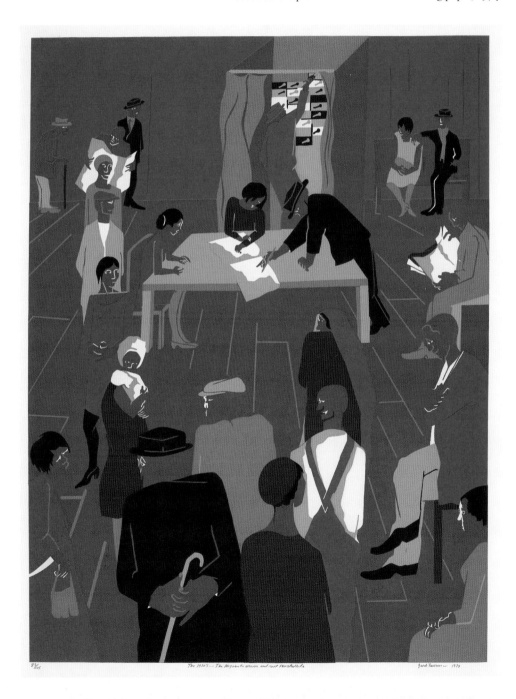

▽ The Black Panther: All Power to the People by Emory Douglas (American, b. 1943), Black Panther Party poster, print, 1970

▷ Buttons, USA: (a) Young Workers Liberation League, 1970s; (b) photo of Angela Y. Davis (b. 1944), 1970–72; (c) photo of Huey Newton (1942–89), Black Panther Movement, 1965–75; (d) quote from Pee Wee Ellis (saxophonist and composer, b. 1941), 1968–80

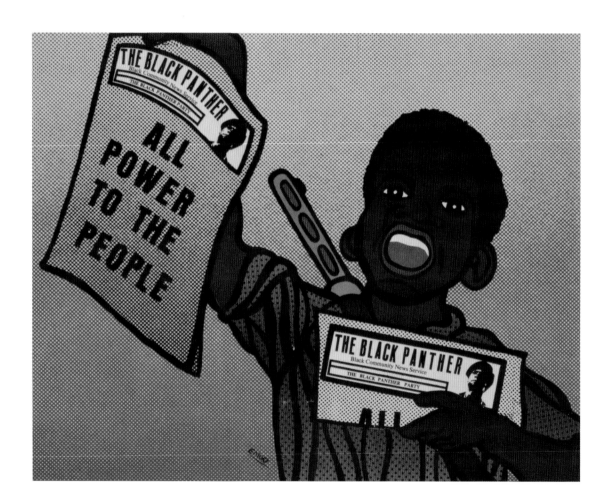

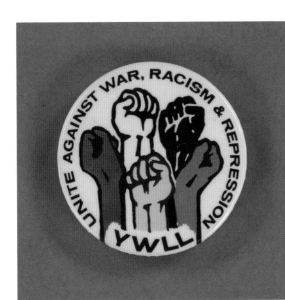

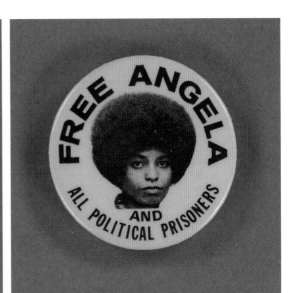

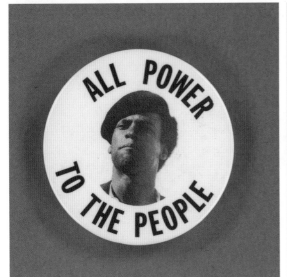

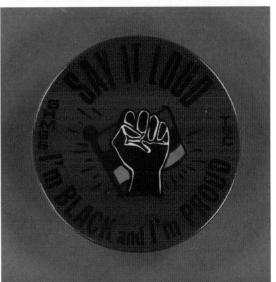

226 ▽ Civil Rights March on Washington, D.C. by Warren K. Leffler (American, 1926–2014), film negative, August 28th, 1963

▷ Black Panther Convention, Lincoln Memorial, Washington D.C. by Thomas J. O'Halloran (American, 1922–2000) and Warren K. Leffler (American, 1926–2014), film negatives, 1970

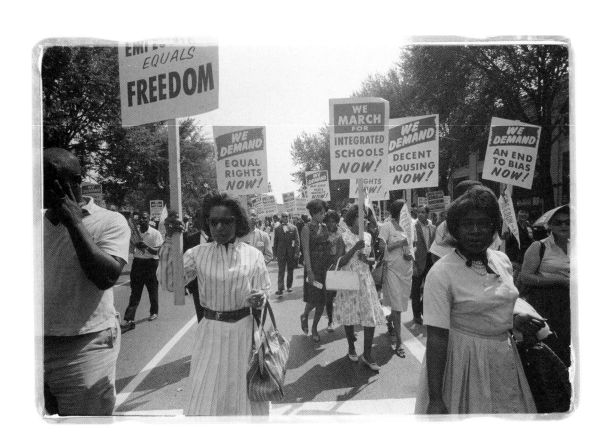

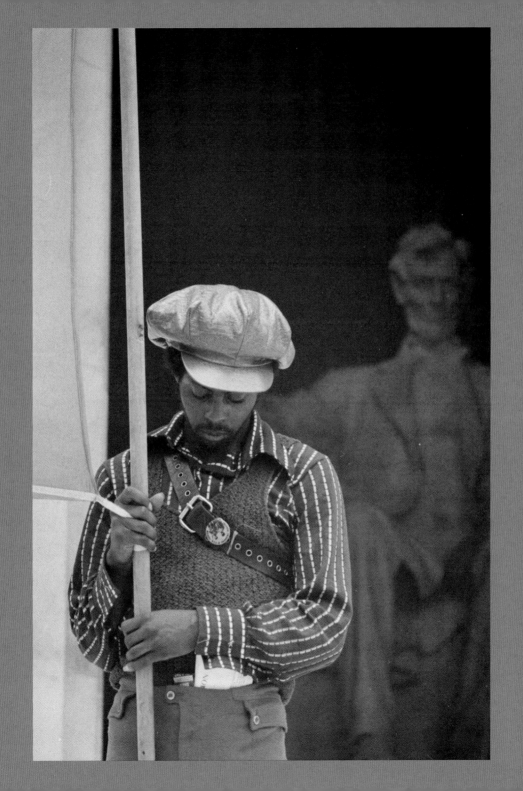

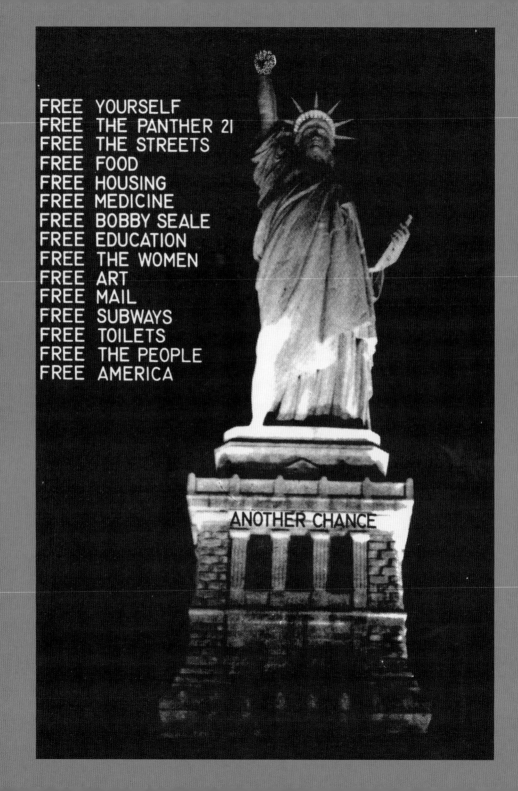

◁ Free Yourself, Free The Panther 21, Free The Streets, Free Food, Free Housing, Free Medicine, Free Bobby Seale, Free Education . . . , unknown artist, print (poster format), American, *c.* 1960–80

▽ We Remember Wounded Knee, 1890–1973 by Bruce Carter (American, b. 1930), poster, printed, *c.* 1973– 1980

229

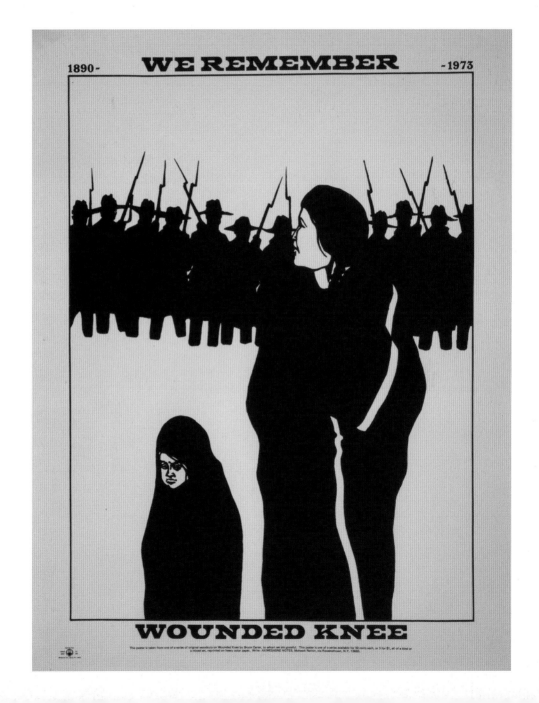

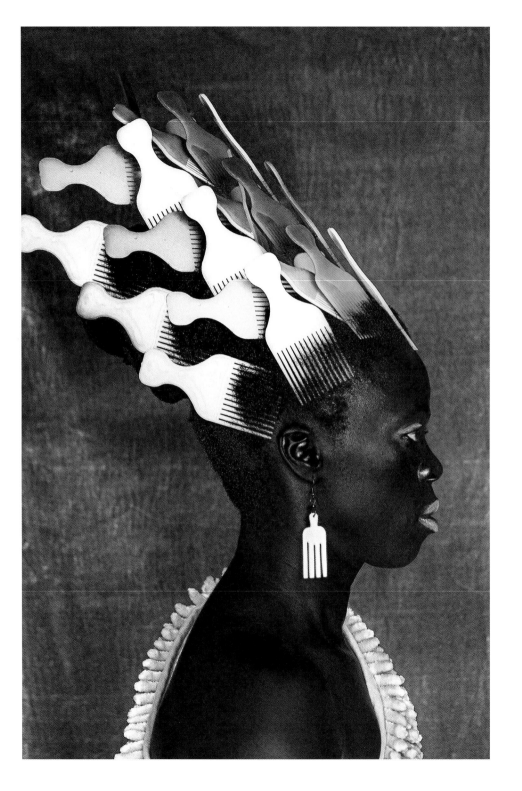

◁ *Qiniso II* by Zanele Muholi (South African, b. 1972), silver gelatin print, 2019

▽ The racist dog policemen must withdraw immediately from our communities, cease their wanton murder and brutality . . . , photo of Huey Newton by Blair Stapp, composition by Eldridge Cleaver (American, 1935–98) print (poster format), 1967

231

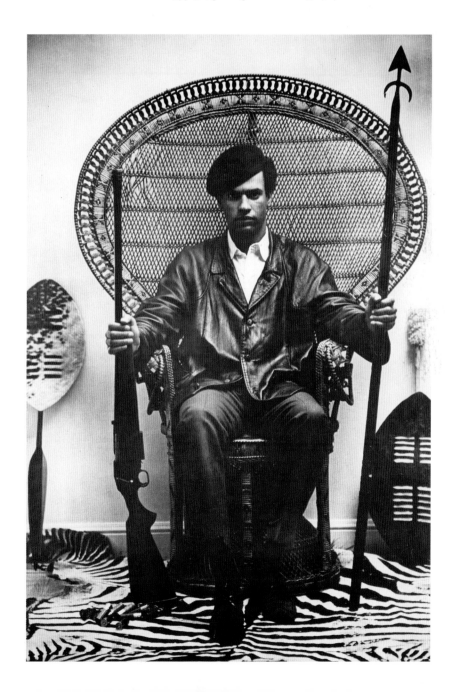

◁ *The Jari Family* by Hao Zeng (Chinese American, b. 1963); stylist: Karina Sharif, models: Jari Jones, Dominique Castelano, Sam Poon, Dwany Guzman, New York, 2020

▽ *Allegory of Charity* by Francisco de Zurbarán (Spanish, 1598–1664), oil on canvas, *c.* 1655

233

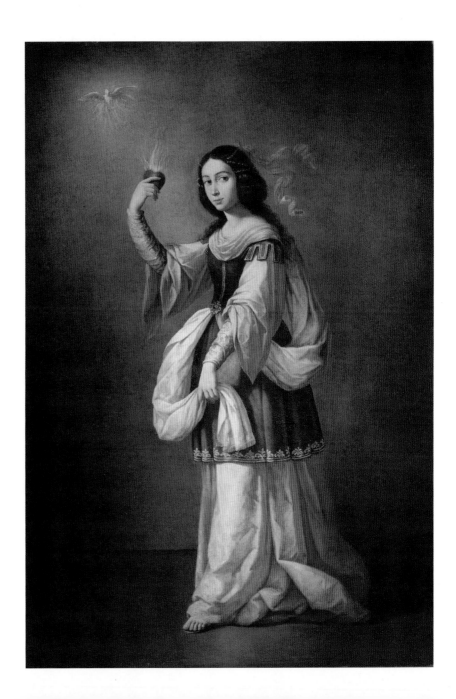

234 ▽ *The Burning of the House of Lords and Commons,*
16 October 1834 by J. M. W. Turner (British, 1775–
1851), oil on canvas, 1835

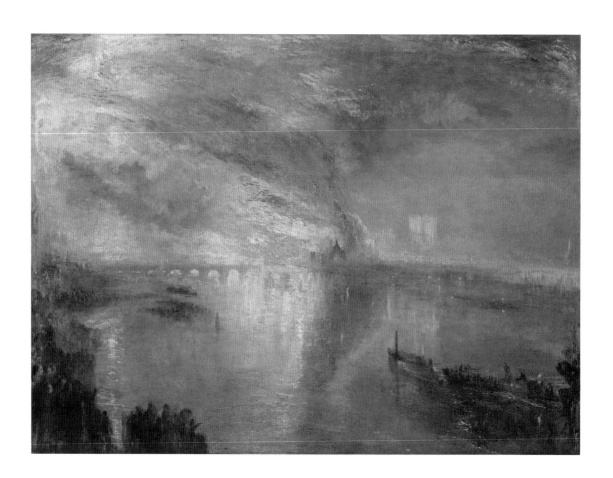

▽ *Legend of St. Francis, 10. Exorcism of the Demons at Arezzo* by Giotto di Bondone (Italian, *c.* 1266–1337), fresco, *c.* 1297–99

▷▷ *Bank of England as a Ruin* aka *A Bird's-Eye View of the Bank of England* by Joseph Michael Gandy (English, 1771–1843), watercolor on paper, 1830

235

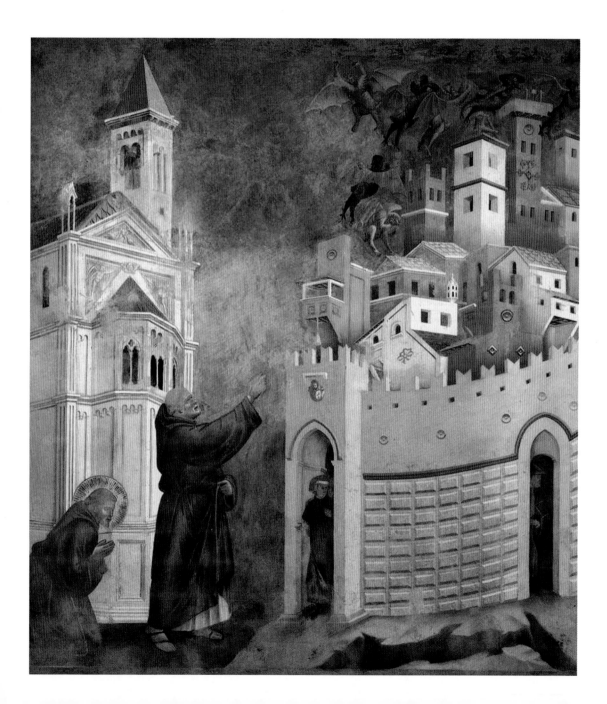

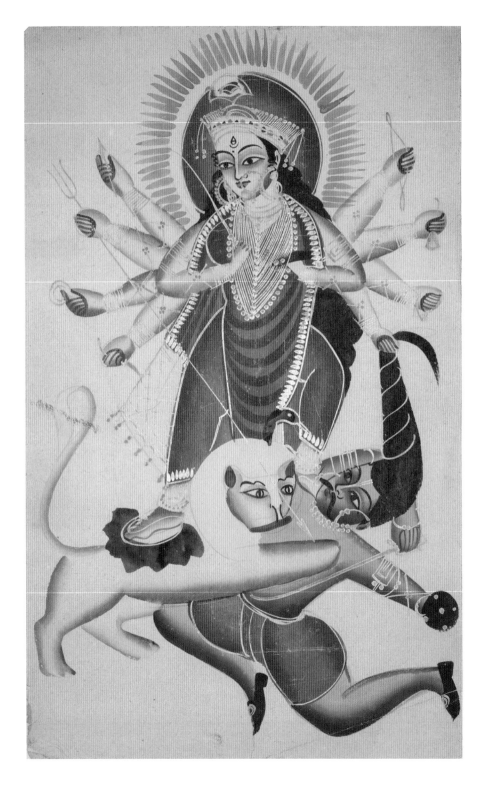

◁ Durga Killing the Demon Mahishaar, unknown Kalighat artist, black ink, watercolor, and tin paint on paper, India, 19th century

▽ Demon in Chains in style of Muhammad Siya Qalam (Iranian, late 14th – early 15th century), opaque watercolor and gold on paper, *c.* 1453. Originally part of the library of early Ottoman sultans, this page shows a male and female leading a captive demon, a Persian div. In the Qur'an divs are often conceptualized as malevolent. In Persian folklore they are sometimes captured by rulers and forced to perform magic.

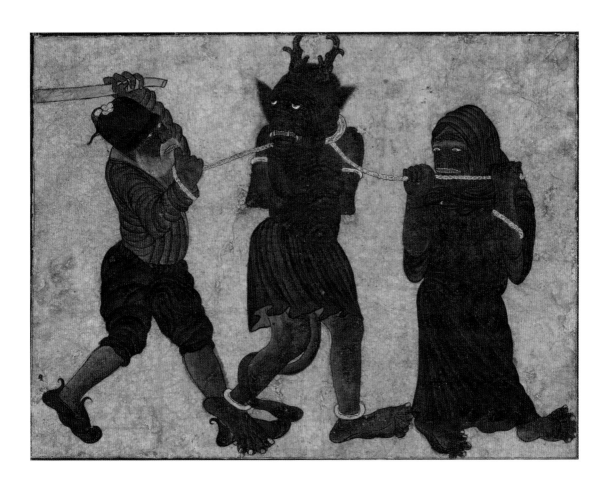

240 ▽ Dante and Virgil Leave Hell (Inferno XXXIV), possibly by Franco dei Russi (Italian, 1455–82) or Guglielmo Giraldi (Italian, 1441–94), from *Divina Commedia* by Dante, Italy, Urbino and Ferrara, *c.* 1477–78

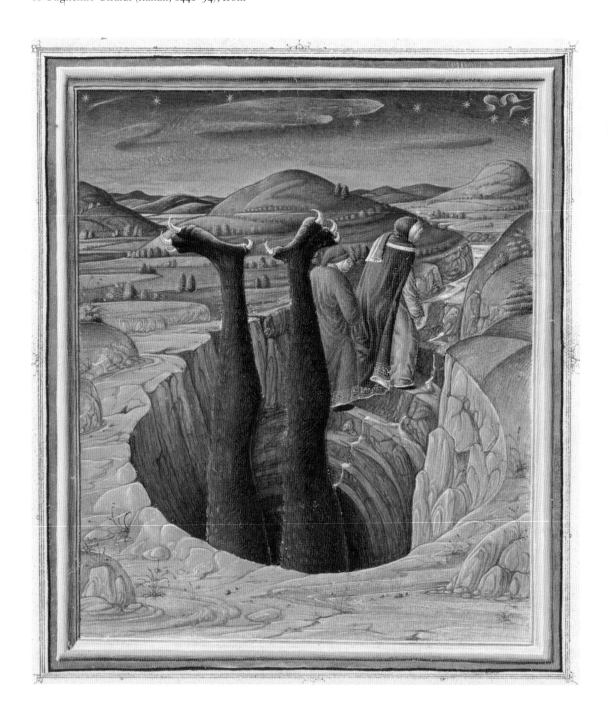

History isn't something you look back at and say it was inevitable, it happens because people make decisions that are sometimes very impulsive and of the moment, but those moments are cumulative realities.

—Marsha P. Johnson, 1992

Hope

You have to act as if it were possible
to radically transform the world.
And you have to do it all the time.

—Angela Y. Davis, from a lecture at Southern Illinois University, Carbondale, 2014

We live in capitalism. Its power seems inescapable—
but then, so did the divine right of kings. Any human
power can be resisted and changed by human beings.

—Ursula K. Le Guin, from a speech at the National Book Awards, 2014

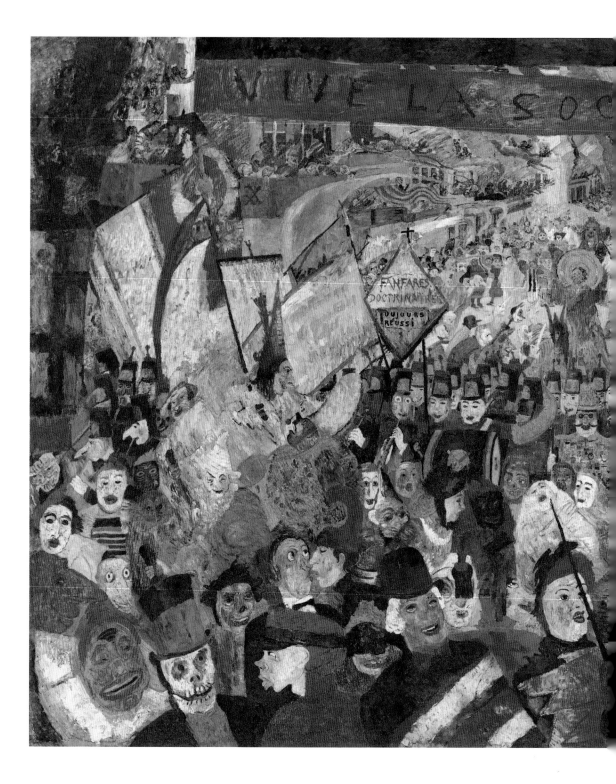

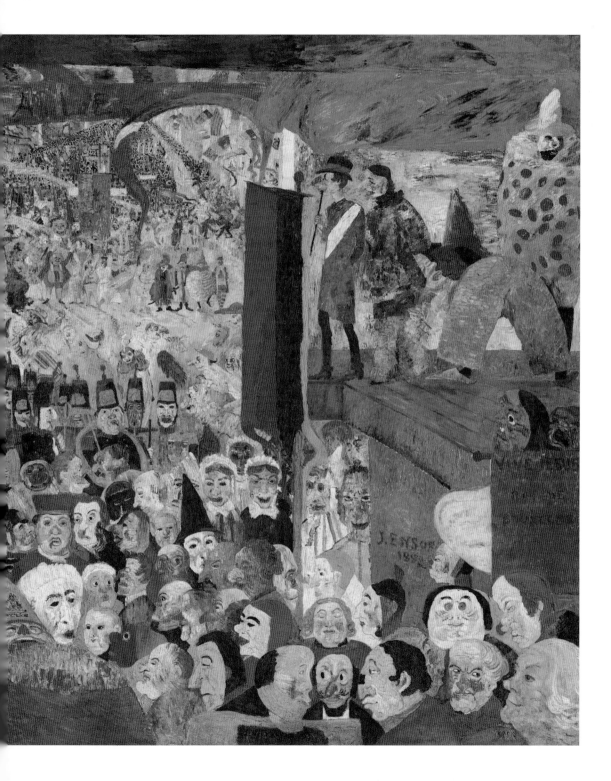

▽ *A Centennial of Independence* by Henri Rousseau (French, 1844–1910), oil on canvas, 1892

▷ *Narcisse*, costume design for Ballets Russes by Léon Bakst (Russian, 1866–1924), watercolor and pencil, sight, France, *c.* 1911

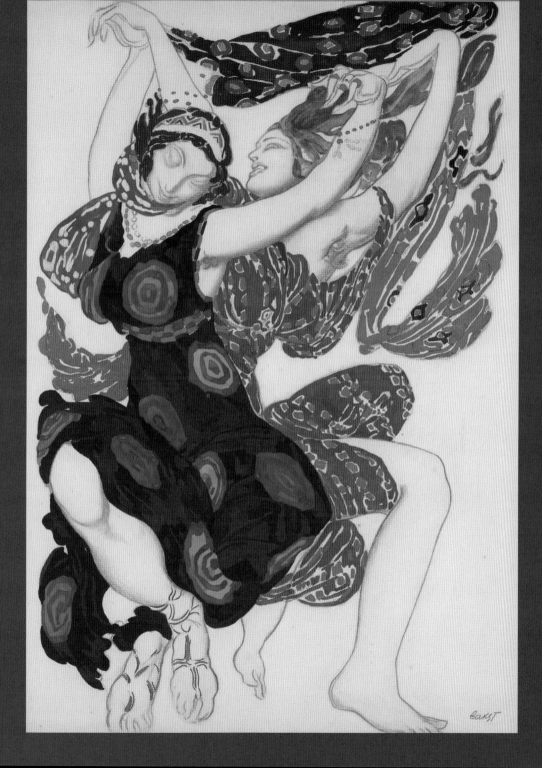

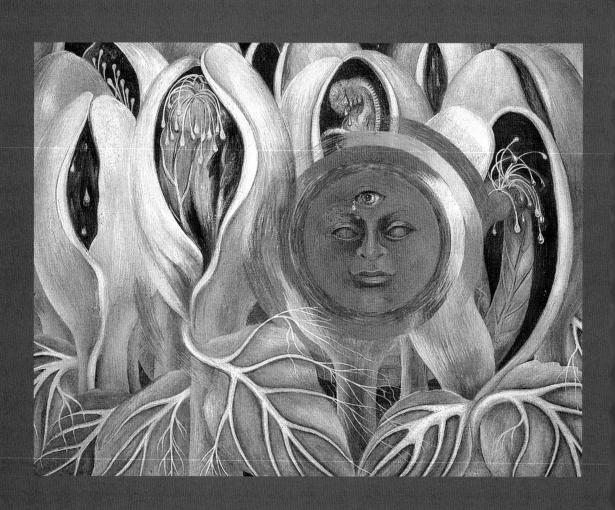

◁ *Sun and Life* by Frida Kahlo (Mexican, 1907–54), oil, maisonite, 1947

▽ A Phoenix, artist unknown, tempera colors, gold leaf, and ink on parchment, Thérouanne, France (formerly Flanders), *c.* 1270

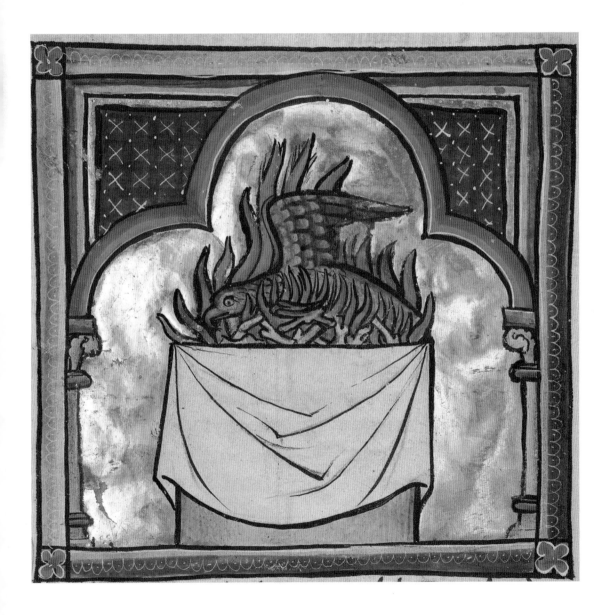

▽ A Christ-like figure seated in a boiling vat while a man works a bellows beneath it; representing the process of self-destruction in order to attain the elixir of life, artist unknown, watercolor, after *Splendor Solis* by Salomon Trismosin (German, late 15th century – early 16th century), 1582

▷ The Hermetic Androgyne; representing the stages of the alchemical Work in One, artist unknown, watercolor, after *Splendor Solis* by Salomon Trismosin (German, late 15th century – early 16th century), 1582

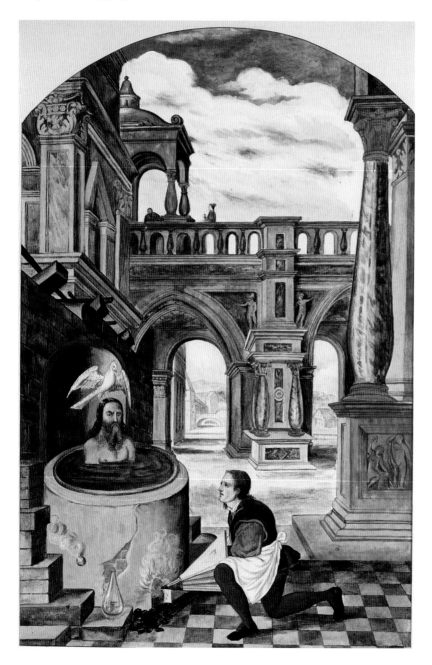

These illustrations, taken from one of the most famous and enigmatic of all surviving alchemical texts, depict different stages in the purification and transformation of the soul. On the left a Christ-like figure in boiling water seeks spiritual purification; on the right, spiritual transformation is represented by a winged androgynous figure. This figure holds a mirror in its right hand, reflecting the natural world, and in its left hand it holds an egg, a symbol that represents all four natural elements.

12·10·31

◁ Untitled by Hilma af Klint (Swedish 1862–1944), watercolor on paper, 1931

▽ *Untitled (New Jerusalem)* by Sister Gertrude Morgan (American, 1900–1980), acrylic and/or tempera, pencil, and ballpoint ink on card, *c.* 1960/70. Sister Gertrude Morgan, who described herself as a "Bride of Christ and housekeeper for Dada God," was a celebrated New Orleans–based self-taught artist and preacher. Inspired by a succession of divine revelations during the late 1950s, she began to paint, transferring her ecstatic visions of a "New Jerusalem" onto scraps of paper and cardboard, claiming that "Jesus just took my hand."

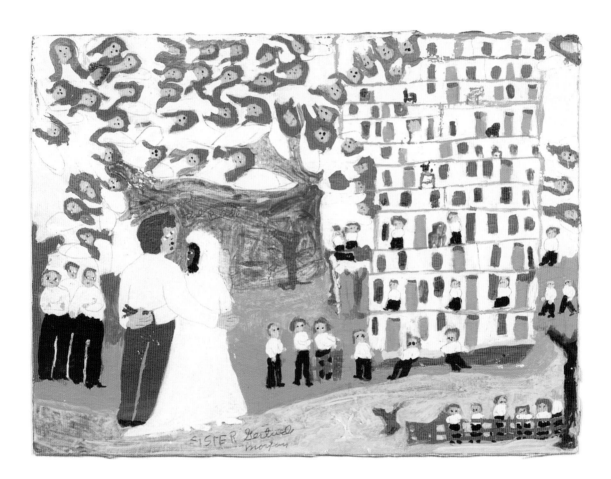

▽ The Pioneer Plaque, designed by Carl Sagan and Frank Drake, artwork by Linda Salzman Sagan, gold anodized aluminum plaque placed onboard the 1972 Pioneer 10 and 1973 Pioneer 11 spacecraft. Intended as a universal message from humanity, the Pioneer plaques were placed on the first spacecraft to escape the solar system.

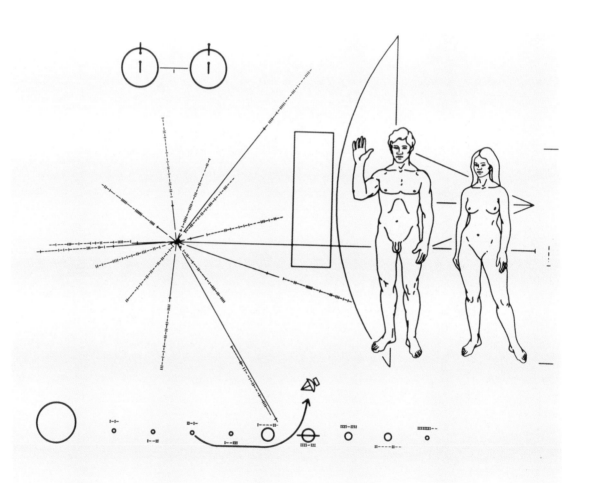

▽ Image taken with a Hasselblad camera by astronaut Charles Duke (American, b. 1935) during the *Apollo 16* moon landing, showing a photograph of Duke's family that he left behind on the lunar surface, April 1972

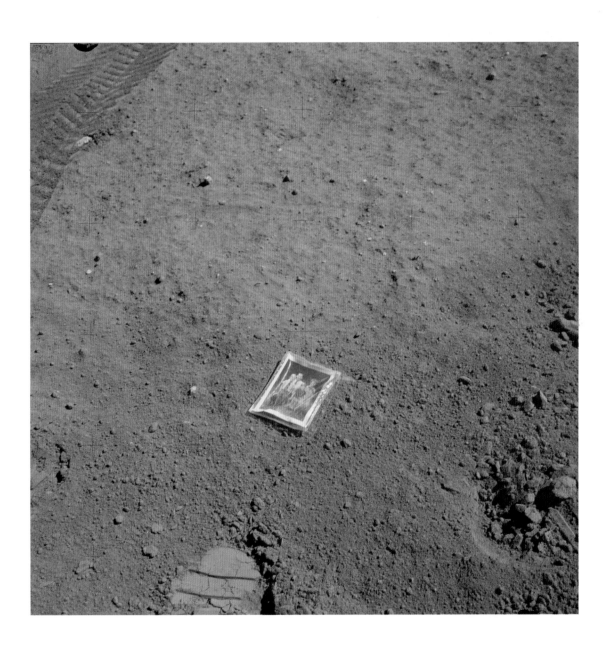

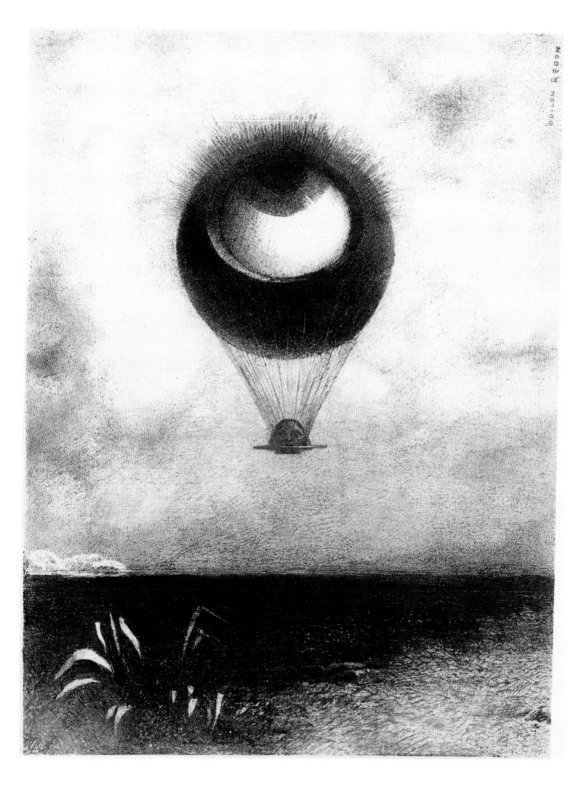

◁ *À Edgar Poe (L'oeil, comme un ballon bizarre se dirige vers l'infini) (To Edgar Poe [The Eye, Like a Strange Balloon, Mounts toward Infinity])* by Odilon Redon (French, 1840–1916), lithograph, 1882

▽ Untitled by Josef Kotzian (Czechoslovakian, 1889–1960), graphite on paper, 1923

259

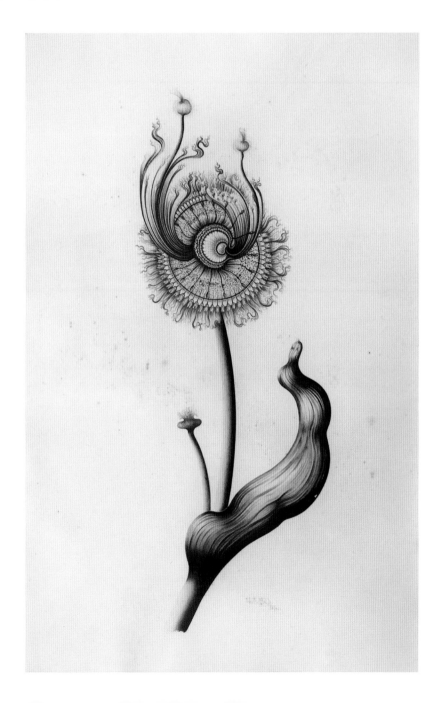

▽ Untitled by Alexandra Duprez (French, b. 1974), oil on wood, 2020 ▷ *Spirit Codex No. 22* by Solange Knopf (Belgian, b. 1957), acrylic, colored pencil, and graphite on paper, 2014

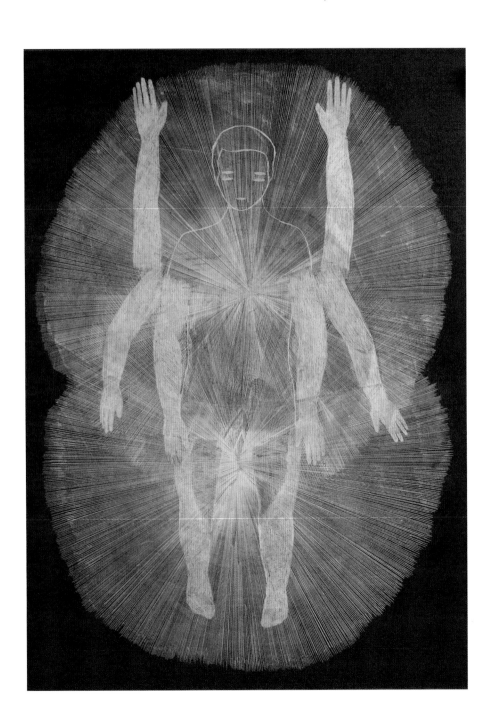

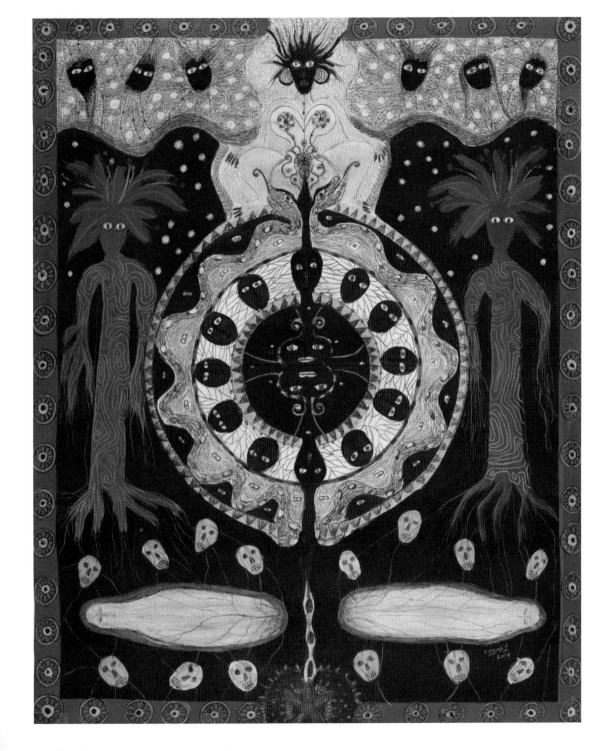

▽ (a) "06-YINQABA" and (b) "53-BAMBUIT" from the
series *The Afronauts* by Cristina De Middel (Spanish,
b. 1975), 2012

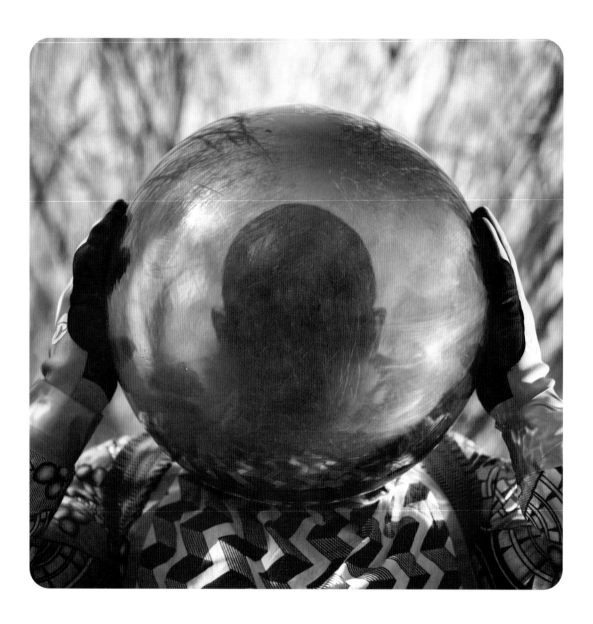

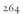 ▽ *One Good Thing* by Esther Pearl Watson (American, b. 1973), acrylic, collage, foil, and glitter on panel, 2019

▽ Untitled by Minnie Evans (American, 1892–1987), oil, pencil, color pencil on board, *c.* 1960. Minnie Evans was an African American artist whose work was inspired by lifelong visions and dreams. She used various media and combined surrealism with religious imagery and botanical and animal forms.

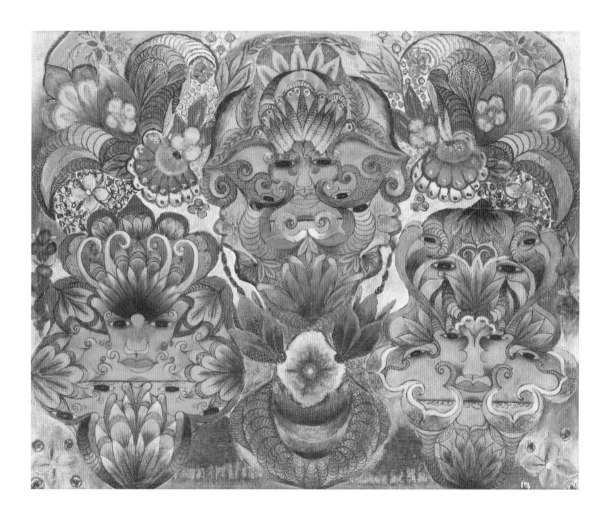

266 ▽ *La Joie de vivre* (*The Joy of Life*) by Max Ernst
(German, 1891–1976), oil on canvas, 1936

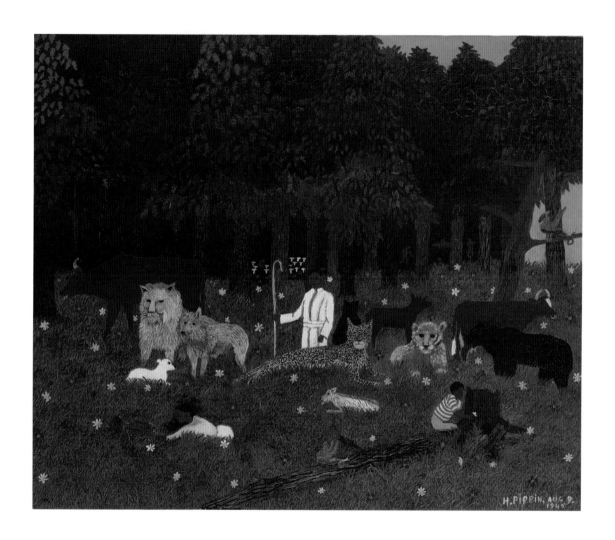

◁ The Buddha Descending from Trayastrimsa Heaven at Sankissa, artist unknown, color on silk, framed, Thailand, 19th century

▽ Durga Pataka, artist unknown, Rajasthan, 19th century. In Hinduism Durga, also known as Shakti or Devi, is the protective mother goddess of the universe, slayer of demons and bringer of light.

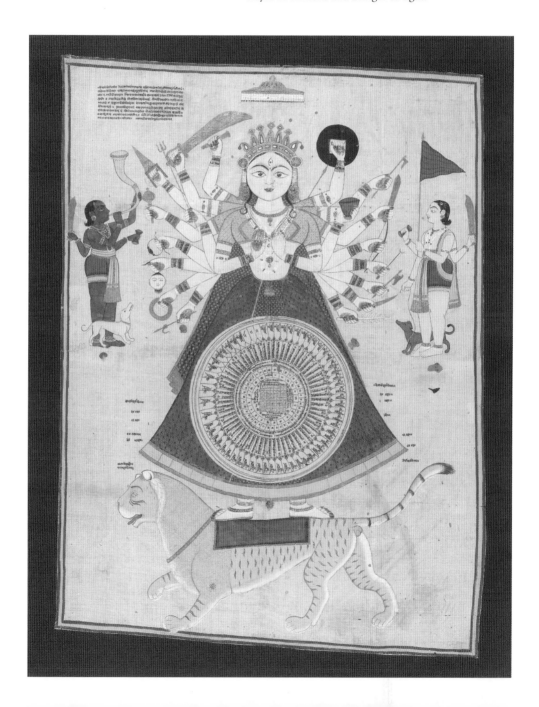

▽ Charity, Transformation, Rebirth. The mahatmya of the tenth adhyaya, artist unknown, Panjabi manuscript. Shiva's servants discover a dead Brahman on Ekadashi, an annual day of cleansing and rejuvenation. The Brahman is delivered to heaven after Shiva explains that, with a holy recitation, he had saved a swan and an apsara, a female spirit, who had been transformed into a lotus.

▷ The Ascension (of Jesus Christ), artist unknown, tempera colors, gold leaf, gold paint, and ink on parchment, France, *c.* 1410

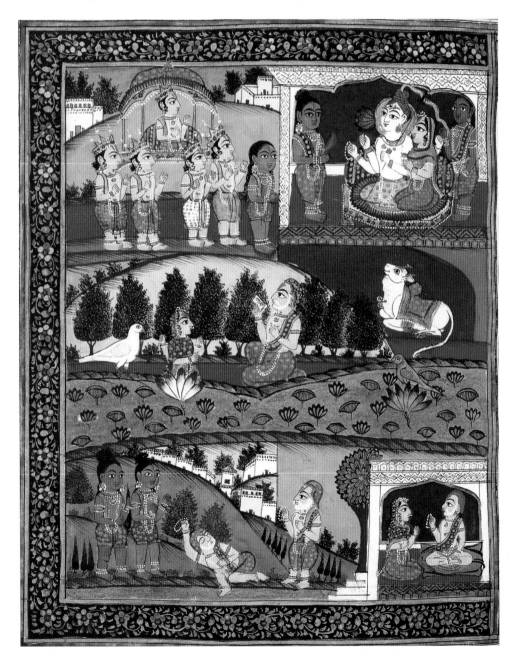

REINCARNATION

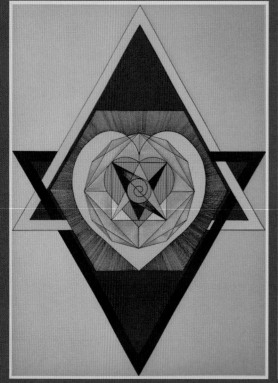

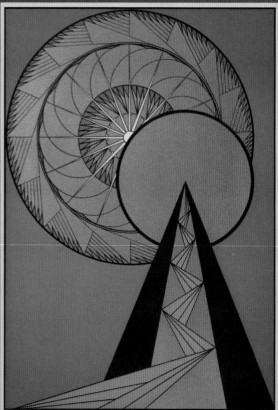

◁ (a) *The Divine Breath*, (b) *Reincarnation*, (c) *The Mystery of Life*, and (d) *The Central Spiritual Sun*, by Olga Fröbe-Kapteyn (Dutch, 1881–1962), color screenprints on paper *c*. 1930. Fröbe-Kapteyn created Eranos, an annual interdisciplinary gathering of scholars interested in spirituality. The psychoanalyst Carl Jung suggested she position Eranos as a "meeting place between east and west." She went on to create the Archive for Research in Archetypal Symbolism, containing over 6,000 images.

▽ Hand of Buddha, artist unknown, wood, Japan, Nara period, 710–794

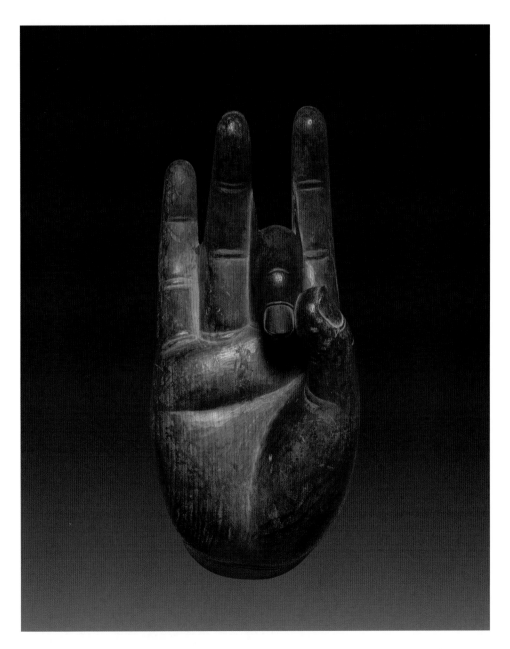

▽ *Sky Above Clouds IV* by Georgia O'Keeffe
(American, 1887–1986), oil on canvas, 1965

▽ *The Sun* by Edvard Munch (Norwegian, 1863–1944),
oil on canvas, 1911–16

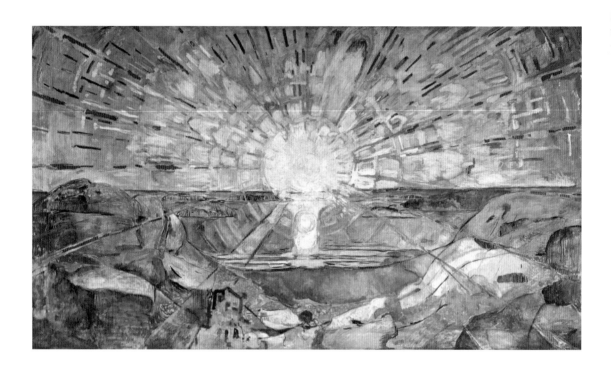

Pray for the dead and fight like hell for the living!

—Mother Jones (Mary Harris Jones), *The Autobiography of Mother Jones*, 1925

Naku te rourou nau te rourou ka ora ai te iwi.

With your basket and my basket the people will live.

—Maori proverb

Go back again, now you have seen us, and your outward
eyes have learned that in spite of all the infallible maxims
of your day there is yet a time of rest in store for the world,
when mastery has changed into fellowship—but not before.
Go back again, then, and while you live you will see all round
you people engaged in making others live lives which are
not their own, while they themselves care nothing for their
own real lives—men who hate life though they fear death.
Go back and be the happier for having seen us, for having
added a little hope to your struggle. Go on living while
you may, striving, with whatsoever pain and labour needs
must be, to build up little by little the new day of fellowship,
and rest, and happiness.

—William Morris, "News from Nowhere," 1890

Credits

Images: Credits, Sources, and Copyright

We have made every attempt to ascertain and contact rights holders. Thank you to the staff of the many galleries, museums, and libraries for your help when backlogged due to the pandemic. Please contact the publishers direct with any comments or corrections: customerservice@papress.com.

Cover
Malevich: Copyright © State Russian Museum, St Petersburg.

Contents and Introduction
Evans: Digital image courtesy of the Getty's Open Content Program.
Cats, et al.: Wikimedia Commons.
Kreitmaier: Archive.org.
Mixelle: Wellcome Collection. Attribution 4.0 International (CC BY 4.0).

SOURCE
Pallandt: 11.8 x 15.75 inches (30 x 40 cm), copyright © Roosmarijn Pallandt.
Bosch: Heritage Image Partnership Ltd / Alamy.
Schematic Map: Bibliothèque nationale de France.
Albarrán Cabrera: Copyright © Albarrán Cabrera.
Marc: The Cleveland Museum of Art, gift of The Print Club of Cleveland.
Buck: 35.4 x 23.6 inches (90 x 60 cm), copyright © Jethro Buck.
Deane: 25.625 x 25.625 inches (65 x 65 cm), copyright © Elisabeth Deane, photo by Justin Piperger.
Shamsa Medallion: Art Institute of Chicago, gift of Guy H. Mitchell.
Kasuga Deer Mandala: The Cleveland Museum of Art, Leonard C. Hanna, Jr. Fund.
Habiballah of Sava: The Metropolitan Museum of Art, Fletcher Fund, 1963.
Bhuri Bai: 48 x 32 inches (121.9 x 81.3 cm), courtesy Cavin-Morris Gallery, NY, photo by Jurate Vecerate.
Blake: Yale Center for British Art, Paul Mellon Collection.
Honilon: Cooper Hewitt, bequest of Mrs. Henry E. Coe.
Spring: Yale University Art Gallery.
De Vos, *Air*: Art Collection 2 / Alamy Stock Photo.
De Vos, *Earth*: Art Collection 2 / Alamy Stock Photo.
Hicks: Historic Images / Alamy Stock Photo.
Palmer: Yale Center for British Art, Paul Mellon Collection.

Welcoming Descent: Wellcome Collection. Attribution 4.0 International (CC BY 4.0).
Celestial Dancer: Metropolitan Museum of Art, gift of Florence and Herbert Irving, 2015.
Meštrovic: 37.8125 x 20.5 x 9.8125 inches (96 x 52.1 x 24.9 cm), Brooklyn Museum, Robert B. Woodward Memorial Fund, 24.280 © Estate of Ivan Meštrovic.

FALL
Rodin: The History Collection / Alamy Stock Photo.
Kupka: Artepics / Alamy Stock Photo.
Punishments of Hell: Wellcome Collection. Attribution 4.0 International (CC BY 4.0).
Prince of the Sinister: Wellcome Collection. Public domain.
Chadewe: Bibliothèque nationale de France.
Cyprianus: Wellcome Collection. Attribution 4.0 International (CC BY 4.0).
Ram: 13 x 17.125 inches (33 x 43.5 cm), Joost van den Bergh, London.
Boaistuau: Wellcome Collection. Attribution 4.0 International (CC BY 4.0).
Doyle: Wellcome Collection. Attribution 4.0 International (CC BY 4.0).
Kali Dancing on Siva: Wellcome Collection. Attribution 4.0 International (CC BY 4.0).
Portents of Death: Wellcome Collection. Attribution 4.0 International (CC BY 4.0).
Martin: Digital image courtesy of the Getty's Open Content Program.
De Brailes: The Walters Art Museum, Baltimore.
De Vos, *Fable*: Album / Alamy Stock Photo.
Caravaggio: Artexplorer / Alamy Stock Photo.
Tree of Intemperance: Wellcome Collection. Attribution 4.0 International (CC BY 4.0).
Tree of Death: Wellcome Collection. Attribution 4.0 International (CC BY 4.0).
Romain: Bibliothèque nationale de France.
Rosa: Digital image courtesy of the Getty's Open Content Program.
Yama: Wellcome Collection. Attribution 4.0 International (CC BY 4.0).

CONNECTIONS
Virgin and Child: Digital image courtesy of the Getty's Open Content Program.
Virgen de Belén: Los Angeles County Museum of Art, gift of Eunice and Douglas Goodan (M.2009.158), photo © Museum Associates/LACMA.
Isis-Aphrodite: Metropolitan Museum of Art, purchase, Lila Acheson Wallace Gift, 1991.

Goulandris Master: The Walters Art Museum, Baltimore, museum purchase, 1993.

Govardhan: Metropolitan Museum of Art, purchase, Rogers Fund and The Kevorkian Foundation Gift, 1955.

Ten Madavidyas: Wellcome Collection. Attribution 4.0 International (CC BY 4.0).

Khan: The Metropolitan Museum of Art, purchase, Friends of Islamic Art Gifts, 2009.

Tantric Figure: Wellcome Collection. Attribution 4.0 International (CC BY 4.0).

Ritual Dish: Metropolitan Museum of Art, purchase, 2017 Benefit Fund, Gordon Sze MD, The Richman Family Foundation, and Steven Kossak Gifts, Andrea Bollt Bequest, in memory of Robert Bollt Sr. and Robert Bollt Jr., and The Ruddock Foundation for the Arts Gift, 2018.

Iverson: National Gallery of Art, Index of American Design.

Muftuoglu: 15 x 8 x 7 inches (38.1 x 20.3 x 17.8 cm), photo courtesy of the artist and Cavin-Morris Gallery, NY, photograph by Jurate Vecerate.

Dance Cape: Metropolitan Museum of Art, Ralph T. Coe Collection, gift of Ralph T. Coe Foundation for the Arts, 2011.

Curtis, Yebichai Sweat: Wellcome Collection. Attribution 4.0 International (CC BY 4.0).

Musavvir: Yale University Art Gallery.

Textile Doll: The Walters Art Museum, Baltimore, 2009, by gift.

Curtis, Wasp: Digital image courtesy of the Getty's Open Content Program.

Bihzad: Metropolitan Museum of Art, Rogers Fund, 1917.

Female Figure: 11.5 x 5.5 x 2.25 inches (29.2 x 14 x 5.7 cm), Brooklyn Museum, Charles Edwin Wilbour Fund, 07.447.505.

Cameron: Cameron Parsons Foundation, Santa Monica, California, from Cameron: Songs for the Witch Woman by John W. Parsons and Marjorie Cameron, published by Cameron-Parsons Foundation/The Museum of Contemporary Art, Los Angeles, 201.

Female Dancer: Metropolitan Museum of Art, gift of Charlotte C. and John C. Weber, 1992.

De Lempicka: Album / Alamy Stock Photo.

Ngoma: Metropolitan Museum of Art, The Crosby Brown Collection of Musical Instruments, 1889.

Easterly: Metropolitan Museum of Art, purchase, W. Bruce and Delaney H. Lundberg and Nancy Dunn Revocable Trust Gifts, 2018.

Plaque: Art Institute of Chicago, Samuel P. Avery Fund.

Bally: © Science Museum / Science & Society Picture Library—all rights reserved.

Catlin: Smithsonian American Art Museum, Gift of Mrs. Joseph Harrison, Jr.

Fayzullah: The Cleveland Museum of Art, gift in honor of Madeline Neves Clapp; gift of Mrs. Henry White Cannon by exchange; bequest of Louise T. Cooper; Leonard C. Hanna Jr. Fund; from the Catherine and Ralph Benkaim Collection.

Wilkinson: Metropolitan Museum of Art, Rogers Fund, 1930.

Hemming: Wellcome Collection.

Tot Sint Jans: Wikimedia Commons.

Two Women Embracing: Wellcome Collection. Attribution 4.0 International (CC BY 4.0).

Curtis, *Hopi Man*: Los Angeles County Museum of Art.

Toulouse-Lautrec: Metropolitan Museum of Art, Rogers Fund, 1951.

Couple Holding Hands: LSE Library, https://www.flickr.com/photos/lselibrary/32285480035/in/photostream/.

Zada: The Metropolitan Museum of Art, gift of Alexander Smith Cochran, 1913.

Rivera: imageBROKER / Alamy Stock Photo.

Comet: FlashbakShop.com.

LOSS

Kollwitz, *Whetting the Scythe*: Historic Images / Alamy Stock Photo.

Brueghel the Younger, *Flatterers*: Heritage Image Partnership Ltd / Alamy Stock Photo.

Piggy Bank: The Cleveland Museum of Art, John L. Severance Fund.

Muller: Yale Center for British Art, Paul Mellon Collection.

Dandridge: Yale Center for British Art, Paul Mellon Collection.

Tiepolo: Statens Museum for Kunst. CC0 1.0 Universal (CC0 1.0).

Brueghel the Younger, *Pissing at the Moon*: Photo © Christie's Images / Bridgeman Images.

Walker: 27 x 39 inches (68.6 x 99 cm), copyright © Kara Walker, courtesy of Sikkema Jenkins & Co., New York.

Weems: (a, b & c) Yale University Art Gallery Janet and Simeon Braguin Fund. © Carrie Mae Weems. Courtesy of the artist and Jack Shainman Gallery, New York.

Von Werefkin: Wikimedia Commons.

Daumier: (a & b) The Walters Art Museum, Baltimore.

Nedeljkovich, Brashich, and Kuharich: Wikimedia Commons.

Balfour: Digital image courtesy of the Getty's Open Content Program.

Mole and Thomas: Library of Congress Prints and Photographs Division LC-USZ62-45985.

Du Bois: Library of Congress, Prints and Photographs

Division, (a) LCCN 2013650430, (b) LCCN 2005676812, (c) LCCN 2013650435, & (d) LCCN 2013650442.

Beggar Next to the Carriage of the English King: BNA Photographic / Alamy Stock Photo.
Strand: Digital image courtesy of the Getty's Open Content Program.
Hine: Digital image courtesy of the Getty's Open Content Program.
Van Gogh, *Shoes*: Metropolitan Museum of Art, purchase, The Annenberg Foundation Gift, 1992.
Dugdale: Museum of the Home, London. Copyright: Joanna Dunham.
Baluschek: 48.4375 x 36.25 inches (123 x 92cm), Milwaukee Art Museum, purchase, with funds from Avis Martin Heller in honor of the Fine Arts Society M2010.49. Photographer: John R. Glembin.
Evans: The Miriam and Ira D. Wallach Division of Art, Prints and Photographs: Photography Collection, The New York Public Library, https://digitalcollections.nypl.org/items/729a9100-bb7b-0132-36a1-58d385a7b928.
Southern Chain Gang: From The New York Public Library, https://digitalcollections.nypl.org/items/0a06f990-7560-0130-b4c4-58d385a7b928.
Herman: Copyright © Estate of Josef Herman via DACS, photo: © Ben Uri Gallery, The London Jewish Museum of Art / Bridgeman Images.
Masereel: Sueddeutsche Zeitung Photo / Alamy Stock Photo.
Grosz, *Metropolis*: agefotostock / Alamy Stock Photo.
Douglas: Schomburg Center for Research in Black Culture, Art and Artifacts Division, The New York Public Library, (a) https://digitalcollections.nypl.org/items/634ad849-7832-309e-e040-e00a180639bb & (b) https://digitalcollections.nypl.org/items/634c04bc-fed3-b0e8-e040-e00a18063c1a.
Van Gogh, *Corridor in the Asylum*: The Metropolitan Museum of Art, bequest of Abby Aldrich Rockefeller, 1948.
Höch: Album / Alamy Stock Photo.
Consalvos: 70.875 x 32.25 inches (179.96 x 81.92 cm), courtesy of The Museum + Gallery of Everything.
Gallagher: Copyright © Ellen Gallagher. Courtesy the artist and Hauser & Wirth. Photo © Tate.
Miller: Copyright © Lee Miller Archives, England 2020. All rights reserved. www.leemiller.co.uk.
Wearing: 22 x 5.5 x 4 inches, base 36 x 15 x 11 inches (56 x 14 x 10 cm, base 92 x 38 x 28 cm), © Gillian Wearing, courtesy Maureen Paley, London.
Bourgeois: 26 x 25 x 30 inches (66 x 63.5 x 76.2 cm), © The Easton Foundation / VAGA at Artists Rights Society (ARS), NY, photograph by Peter Bellamy.

Neshat: Print unframed: 66 x 46.125 inches (167.6 x 117.2 cm), framed: 69.625 x 50.0625 inches (176.8 x 127.2 cm), courtesy of The Cleveland Museum of Art, purchased with funds donated by William and Margaret Lipscomb in celebration of the museum's centennial 2016.59. Used with permission of the artist.

LIES
Lorenzetti: Mondadori Portfolio/Electa/Antonio Quattrone / Bridgeman Images.
Beardsley: Art Institute of Chicago, The Charles Deering Collection.
Posada: The Metropolitan Museum of Art, gift of Roberto Berdecio, 1960.
Capitalist Culture: Wikimedia Commons.
Piranesi: (a & b) Yale University Art Gallery.
Bertrand: Metropolitan Museum of Art, gift of Mrs. Algernon S. Sullivan, 1919.
De Zurbarán, *Agnes Dei*: Wikimedia Commons.
Man on Horseback: Wellcome Collection. Attribution 4.0 International (CC BY 4.0).
Moor: Wikimedia Commons.
Heath: The Walters Art Museum, Baltimore.
Rops: www.lacma.org.
Grosz, *God of War*: Peter Barritt / Alamy Stock Photo.
Ensor, *Skeletons Fighting*: PvE / Alamy Stock Photo.
De Goya: Album / Alamy Stock Photo.
Guston: Digital image, The Museum of Modern Art, New York\Scala, Florence.
Dix: Artepics / Alamy Stock Photo.
Kollwitz, *Mothers*: Artokoloro / Alamy Stock Photo.
Fenton: Digital image courtesy of the Getty's Open Content Program.
Wilderness Battlefield: Metropolitan Museum of Art, Gilman Collection, Purchase, The Horace W. Goldsmith Foundation Gift, through Joyce and Robert Menschel, 2005.
Lange: Library of Congress Prints and Photographs Division, LC-USF34-018269-C.
Rothstein: Library of Congress, LC-USF34-002485-D.
Colman: Yale Center for British Art, Paul Mellon Collection.
Church: Cooper Hewitt, donated by Louis P. Church.
Remington: Art Collection 3 / Alamy Stock Photo.

RISE
Gakutei: www.lacma.org, gift of Caroline & Jarred Morse.
Redon, *Armor*: The Metropolitan Museum of Art, Harris Brisbane Dick Fund, 1948.
Richebourg: Metropolitan Museum of Art, purchase, The Horace W. Goldsmith Foundation Gift, through Joyce and Robert Menschel, 1998.

Dürer: Metropolitan Museum of Art, gift of Henry Walters, 1917.

Crane: University of Michigan Library (Special Collections Research Center, Joseph A. Labadie Collection).

Abolitionist Jug: Metropolitan Museum of Art, purchase, Brett and Sara Burns Gift, in honor of Austin B. Chinn, 2020.

Bock: Library of Congress Prints and Photographs Division.

Banner: Metropolitan Museum of Art, gift of Mrs. John H. Ballantine, 1947.

Death of Munrow: The Metropolitan Museum of Art, purchase, funds from various donors, The Charles E. Sampson Memorial Fund, and The Malcolm Hewitt Wiener Foundation Gift, in memory of George Munroe, 2016.

Gentileschi: GL Archive / Alamy Stock Photo.

Stokes-Preindlsberger: Painters / Alamy Stock Photo.

Cahun: Album / Alamy Stock Photo.

Men in Drag: (a–d) Wellcome Collection. Public domain.

Stahl: Metropolitan Museum of Art, funds from various donors, 2011.

Woman Beating a Man: Joost van den Bergh, London.

Hero Holding a Banner: Wellcome Collection. Attribution 4.0 International (CC BY 4.0).

Long Live the Fifth Anniversary: Russian State Library.

Dallas: Schlesinger Library, Radcliffe Institute, Harvard University.

Cary: Schlesinger Library, Radcliffe Institute, Harvard University.

Reminick: Library of Congress Prints and Photographs Division.

Suffrage in the press: (a, b, c, & d) LSE Library, The Women's Library.

Savage: From The New York Public Library, https://digitalcollections.nypl.org/items/af92a120-1155-0134-7ad2-00505686a51c.

Advance Swiftly: Shawshots / Alamy Stock Photo.

Palmer: Library of Congress Prints and Photographs Division.

Lissitzky: incamerastock / Alamy Stock Photo.

POUM poster: World History Archive / Alamy Stock Photo.

Modotti: Heritage Image Partnership Ltd / Alamy Stock Photo.

Klee: akg-images.

Lawrence: Copyright © Estate of Jacob Lawrence via DACS, photo: Albright-Knox Art Gallery / Art Resource, NY/ Scala, Florence.

Douglas: Library of Congress Prints and Photographs Division.

Buttons: Schomburg Center for Research in Black Culture, Art and Artifacts Division, The New York Public Library, (a) https://digitalcollections.nypl.org/items/c66f5df0-6be8-0135-cb9b-033bb84ff8da, (b) https://digitalcollections.nypl.org/items/d11033c0-6be8-0135-adb8-395f37da49bd, (c) https://digitalcollections.nypl.org/items/c9e83030-6be8-0135-6bb0-0550f5bf58c1, & (d) https://digitalcollections.nypl.org/items/bba504e0-6be8-0135-d81b-057a2c1c87b8.

Leffler: Library of Congress, https://lccn.loc.gov/2003654393.

O'Halloran and Leffler: Library of Congress, https://lccn.loc.gov/2003688171.

Free Yourself: Library of Congress, https://lccn.loc.gov/2015649390.

Carter: Library of Congress, https://lccn.loc.gov/2015649244.

Muholi: Copyright © Zanele Muholi, with thanks to the Stevenson Gallery.

Stapp: Library of Congress Prints and Photographs Division, LC-USZC4-1564.

Zeng: Copyright © Hao Zeng.

De Zurbarán, *Allegory of Charity*: Asar Studios / Alamy Stock Photo.

Turner: The Cleveland Museum of Art, bequest of John L. Severance.

Di Bondone: Art Heritage / Alamy Stock Photo.

Gandy: Bridgeman Images.

Durga: The Cleveland Museum of Art, gift of William E. Ward in memory of his wife, Evelyn Svec Ward.

Demon in Chains: The Cleveland Museum of Art, purchase from the J.H. Wade Fund.

Dei Russi or Giraldi: Biblioteca Apostolica Vaticana.

HOPE

Gotch: Photo © The Maas Gallery, London / Bridgeman Images.

Ensor, *Christ's Entry*: Album / Alamy Stock Photo.

Rousseau: Digital image courtesy of the Getty's Open Content Program.

Bakst: From The New York Public Library https://digitalcollections.nypl.org/items/0a06f990-7560-0130-b4c4-58d385a7b928.

Kahlo: The Artchives / Alamy Stock Photo.

Phoenix: Digital image courtesy of the Getty's Open Content Program.

Boiling Vat: Wellcome Collection. Attribution 4.0 International (CC BY 4.0).

Hermetic Androgyne: Wellcome Collection. Attribution 4.0 International (CC BY 4.0).

Af Klint: 13 x 9.875 inches (33 x 25 cm), courtesy of The Museum + Gallery of Everything.

Quotations: Credits, Sources, and Copyright

INTRO

Lorde, "Master's Tools": From "The Master's Tools Will Never Dismantle the Master's House," in *Sister Outsider: Essays and Speeches.* Ed. (Berkeley, CA: Crossing Press), reprinted by permission of Abner Stein.

Debs: Eugene Victor "Gene" Debs was an American socialist, political activist, trade unionist, and one of the founding members of the Industrial Workers of the World (IWW, also known as the "Wobblies.")

Dickinson: http://archive.emilydickinson.org.

Behan: As quoted in the *Irish Post*, June 24, 2014: https://www.irishpost.com/entertainment/the-influence-of-brendan-behans-women-on-tom-obriens-latest-play-29667.

SOURCE

Butler: *Parable of the Sower* copyright © 1993 by Octavia E. Butler. Reprinted by permission of Writers House LLC acting as agent for the Estate and Hodder & Stoughton.

Chief Luther Standing Bear: *From My People the Sioux*, first published by The Riverside Press in 1928, currently available from Bison Books, Nebraska.

Donne: From the poem "Community," date unknown.

Blake: "The Song of Enitharmon over Los," from the unfinished work *The Four Zoas*, which was to be an epic poem in nine books, 1796–1802.

FALL

Lorde, *Cancer Journals*: Excerpt from *The Cancer Journals* by Audre Lorde, copyright © 1980 by Audre Lorde. Used in the US by permission of Penguin Classics, an imprint of Penguin Publishing Group, a division of Penguin Random House LLC. All rights reserved. Reprinted in the UK with permission of Abner Stein.

James: From *The Black Jacobins* by C. L. R. James, first published in 1938, published by Penguin Books with a new introduction in 2001. Reproduced with permission of Curtis Brown Ltd, London, on behalf of the Estate of C. L. R. James. Copyright © C. L. R. James, 1938.

Shakespeare: From *King Lear*, Act 4, Scene 1, 1605–06.

Said: Excerpt from *Orientalism* by Edward W. Said, copyright © 1978 by Edward W. Said. Used by permission of Pantheon Books, an imprint of the Knopf Doubleday Publishing Group, a division of Penguin Random House LLC. All rights reserved.

Dann: From the Twin Lakes Cultural Park website, http://www.twinlakes.net.au/page11/page11.html.

Reprinted by permission of Bruno Alphonse Dann, Nyul Nyul elder, cofounder Twin Lakes Cultural Park.

Murdoch: From "The Sublime and the Good," *Chicago Review*, vol. 13, no. 3, 1959. Reprinted by permission of *Chicago Review*.

Winstanley: From *The True Levellers Standard Advanced: Or, The State of Community Opened, and Presented to the Sons of Men* by William Everard, John Palmer, John South, John Courton, William Taylor, Christopher Clifford, John Barker, Ferrard Winstanley, Richard Goodgroome, Thomas Starre, William Hoggrill, Robert Sawyer, Thomas Eder, Henry Bickerstaffe, John Taylor, &c., printed in London, 1649.

Paine: *The American Crisis*, a pamphlet series used to "recharge the revolutionary cause," published during the American Revolution, between 1776 and 1783.

LOSS

Benjamin: *The Arcades Project* by Walter Benjamin, translated by Howard Eiland and Kevin McLaughlin, published by The Belknap Press of Harvard University Press, Cambridge, Massachusetts. Copyright © 1999 by the President and Fellows of Harvard College. Reprinted with permission.

Eliot: *Felix Holt, the Radical*, about the First Reform Act of 1832, published by William Blackwood and Son, Edinburgh and London, 1866.

Tressell: *The Ragged-Trousered Philanthropists*, the semi-autobiographical novel written by Irish house painter and sign writer Robert Noon, published after his death, in 1911, by Grants Richards Ltd, London, in 1914.

Lorca: The Spanish poet and playwright was executed by a Nationalist firing squad in the first months of the Spanish Civil War.

Alexievich: *Chernobyl Prayer: Voices From Chernobyl* by copyright © Svetlana Alexievich 2016, published by Penguin Classics 2016. Reproduced by permission of Penguin Books Ltd and Galina Dursthoff.

LIES

Hughes: "Tired," 1994 by The Estate of Langston Hughes; from *The Collected Poems Of Langston Hughes* by Langston Hughes, edited by Arnold Rampersad with David Roessel, Associate Editor. Used by permission of Alfred A. Knopf, an imprint of the Knopf Doubleday Publishing Group, a division of Penguin Random House LLC, and David Higham Associates. All rights reserved.

McLuhan: From *Culture is Our Business*, Balantine Books, 1970, Wipf and Stock, Eugene, Oregon, 2014. Reprinted with permission.

Wilson: From a debate at the Harvard Museum of

Natural History, Cambridge, Massachusetts, September 9th, 2009, and quoted in "An Intellectual Entente," *Harvard Magazine*, 2009. Reprinted with the permission of E. O. Wilson.

Graeber: From *The Utopia of Rules: On Technology, Stupidity, and the Secret Joys of Bureaucracy*, published Melville House, 2015. Reprinted with permission.

Bakunin: From *Statism and Anarchy*, 1873, translated by Marshall S. Shatz, Cambridge University Press, 1990. Copyright © in the English language translation and editorial matter Cambridge University Press 1990. Reproduced with permission of Cambridge University Press through PLSclear.

Genet: From *The Balcony*, translated by Bernard Frechtman, 1957, published in the UK by Faber, 2009, and in the US by Grove Atlantic, 1994. Copyrights © 1966 by Jean Genet and Bernard Frechtman. Reprinted with permission of Grove/Atlantic, Inc., and Rosica Colin on behalf of the Estate of Jean Genet.

RISE

Rābi'a al-'Adawiyya al-Qaysiyya: as quoted in *Shorter Encyclopaedia of Islam* by H. A. R. Gibbs and J. H. Kramers, Pentagon Press, 2008, p. 463a.

Rich: From "When We Dead Awaken: Writing as Re-Vision," *College English*, vol. 34, no. 1, 1972. Reprinted with permission.

Baldwin: Excerpt(s) from *Native Sons: A Friendship That Created One Of The Greatest Works Of The 20th Century: Notes Of A Native Son* by James Baldwin, copyright © 2004 by The Estate of James Baldwin and Sol Stein. Used by permission of Ballantine Books, an imprint of Random House, a division of Penguin Random House LLC. All rights reserved.

Kahf: Mohja Kahf (b. 1967) is a Syrian American poet, novelist, activist, and professor of Islamic Studies, Literature, and Cultural Studies. Quotation is from *E-mails from Scheherazad*, University Press of Florida, 2003. Reprinted with permission.

Johnson: Marsha P. Johnson (1945–1992) was a drag performer and prominent figure in the Stonewall Uprisings, cofounder of STAR (Street Transvestite Action Revolutionaries).

HOPE

Davis: Reprinted with permission of the author.

Le Guin: Copyright © 2014 Ursula K. Le Guin. Reprinted with permission.

Jones: *The Autobiography of Mother Jones*, first published in Chicago by Charles H. Kerr & Company, 1925.

Maori proverb: quoted in the *If Not Us Then Who* series of short films, www.ifnotusthenwho.me.

▷▷ Sunt Porta Malorum CLXXVII from *Regula Emblematica Sancti Benedicti* by Bonifaz Gallner (Italian, 1678–1727), published by Vindobonae Apud Carl Wilhelm Holle, 1783

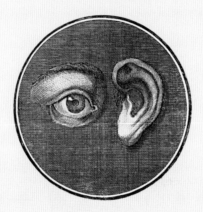

I would like to thank Esther Sooroshian for all her support,
hard work, encouragement, and inspiration; Max Wood for coming
to my rescue at my moment of maximum incapacity and minimum
mobility; and Hannah MacDonald, Charlotte Cole, Friederike Huber,
Rob Shaeffer, and Kristen Hewitt for their time, patience, and
invaluable contributions and assistance during the
preparation and creation of this book.

I would also like to express my deep gratitude to all the
artists, galleries, museums, institutions, and estates who have
so generously granted us permission to feature their work—
the book would not exist without them.

Stephen Ellcock, 2021